Remembering Christmas in Chicago

Rosemary K. Adams

TURNER
PUBLISHING COMPANY

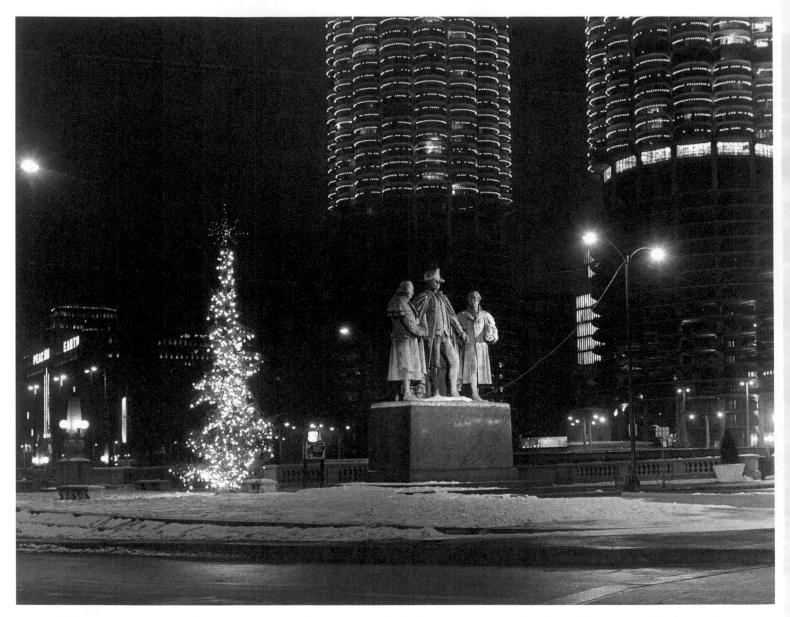

A Christmas tree at Wabash and Wacker, December 1969. Lorado Taft's monument featuring George Washington clasping hands with Robert Morris and Hyam Salomon, who helped finance the American Revolution, appears at right. In the background, Marina Towers, popularly known as the "corn cob buildings," is outlined in Christmas lights.

Remembering
Christmas in Chicago

Turner Publishing Company
www.turnerpublishing.com

Remembering Christmas in Chicago

Copyright © 2010 Turner Publishing Company

Library of Congress Control Number: 2010926219

ISBN: 978-1-59652-696-9

Printed in the United States of America

ISBN: 978-1-68442-241-8 (pck.)

Contents

Even in the heart of the city, Chicago takes on old-fashioned country charm after a snowfall, as in this view of Lincoln Park.

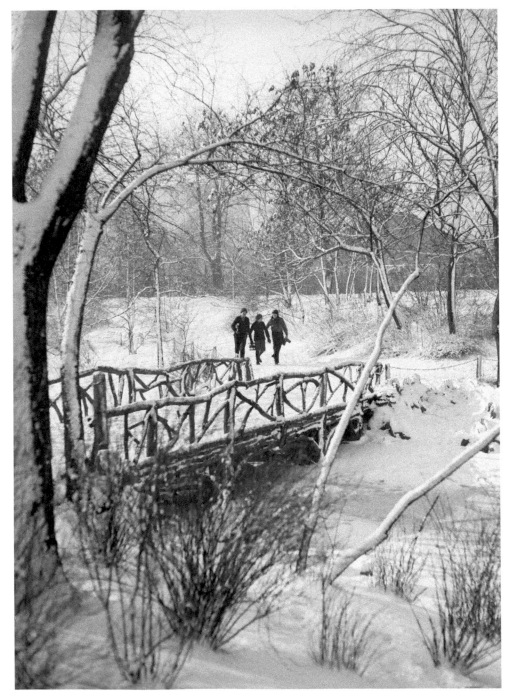

ACKNOWLEDGMENTS

With the exception of cropping images where needed and touching up imperfections that have accrued with the passage of time, no changes have been made to the photographs in this volume. The caliber and clarity of many photographs are limited by the technology of the day and the ability of the photographer at the time they were made.

This volume, *Remembering Christmas in Chicago,* is the result of the cooperation and efforts of many individuals and organizations. It is with great thanks that we acknowledge the valuable contribution of the Chicago History Museum for its generous support.

———————

I would like to thank Rob Medina, rights and reproduction coordinator at the Chicago History Museum, in particular for his work on this book. His knowledge of the photography collection and his coordination of the image scanning were invaluable. Photographers John Alderson and Jay Crawford brought their usual professionalism and expertise to the digital imaging process. Simone Martin-Newberry organized the photography orders with a great eye for detail. Publications interns Laurie Stein and Catherine Gladki provided invaluable assistance for this book. I also am grateful for the support of Gary Johnson, president; Russell Lewis, executive vice president and chief historian; and Phyllis Rabineau, vice president for interpretation and education, for their support on this project.

—*Rosemary K. Adams*

For my parents, Kenneth and Irene Adams

PREFACE

As the twentieth century dawned in Chicago, expectations for the twenty-first century far ahead were dim, as this futuristic vision in a *Chicago Tribune* editorial from December 1900 revealed:

> *Christmas in the year 2000 dawned bright and clear over Chicago, only that comparatively few persons were interested in it in that early stage. Santa Claus and St. Nicholas had been myths for seventy-five years, and the ravages of the twenty-five years before had stripped the north woods of their evergreens. The reindeer was extinct and the furry robes once accredited to these guardian genii of Christmas were to be found only in museums of natural history. . . . The spirit of Christmas became lost.*

It appeared that the abundant fears of the unknown and the worst possible scenario imaginable could be summed up with the disappearance of Christmas, a fate that seemed grim indeed.

Happily, like many visions of the future, this one has not been realized. American cities have changed dramatically over the past century, and in viewing images of Chicago at Christmas during this era, it is

tempting to focus on the differences from one decade to the next. But what are more striking are the similarities: Chicago of the twenty-first century celebrates Christmas with as much enthusiasm and with many of the same traditions as it has for much of its history. In 1900, Chicagoans bought fresh Christmas trees on corner lots, crowded State Street in search of the perfect gifts for family and friends, dropped coins in Salvation Army baskets to help the less fortunate, and dreamt of a white Christmas. New customs gradually became traditions: the city's first official Christmas tree appeared in 1913, and Marshall Field and Company on State Street became nearly synonymous with the holiday with its whimsical windows and famed Walnut Room tree. Celebrating Christmas today—whether in your home, your neighborhood, or on State Street—remains a familiar part of city life.

In Charles Dickens's *A Christmas Carol,* Ebenezer Scrooge had the unique opportunity to visit Christmas past, present, and future one unforgettable night, and he came to understand how each of them is but one part of the great tradition of Christmas. It is not surprising that the story unfolds in London. Dickens understood how cities were transforming his nineteenth-century world, and *A Christmas Carol* thus gives the tradition of Christmas a special place in the whirl of a rapidly changing city. Today, despite our hurried pace—or perhaps because of it—the holiday season is a time to reflect on Chicago and the world and to feel the flood of memories of Christmas past as we look to Christmas future.

—*Rosemary K. Adams*

Mailman N. Sorenson poses with his heavy load of Christmas mail and parcels, 1929.

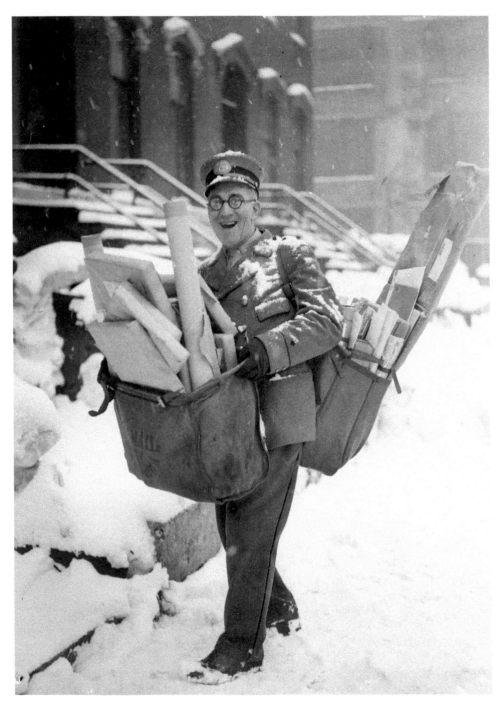

Beginning to Look a Lot like Christmas

Decorating the City

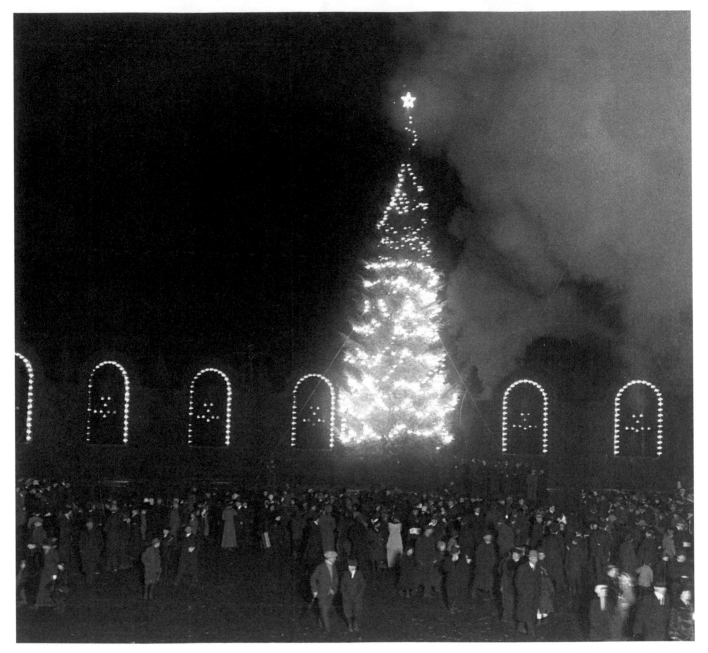

New York City claims to have decorated the nation's first official civic Christmas tree in 1912. Chicago offered its own version for residents in 1913.

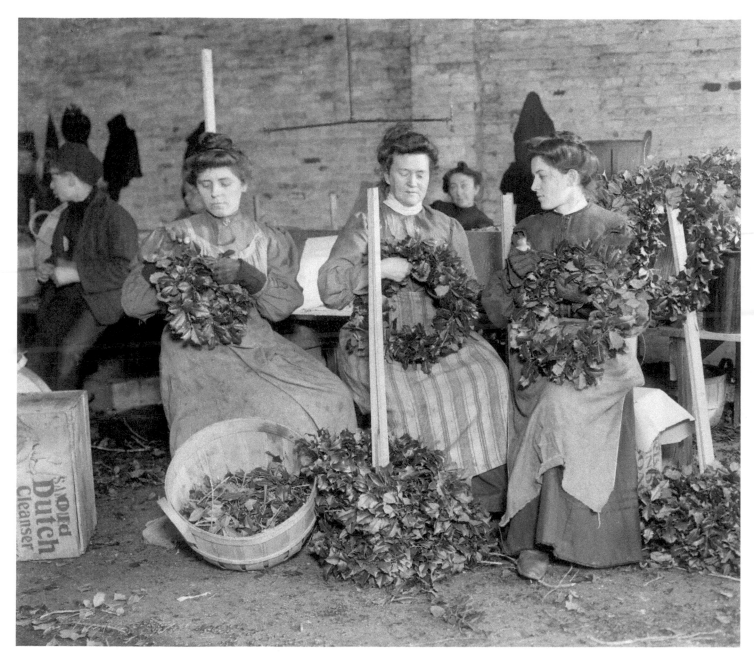

A group of women make Christmas wreaths, around 1906.

Santa peeks out from an ad for Maurice L. Rothschild & Company on the side of a shop, at left, 1905.

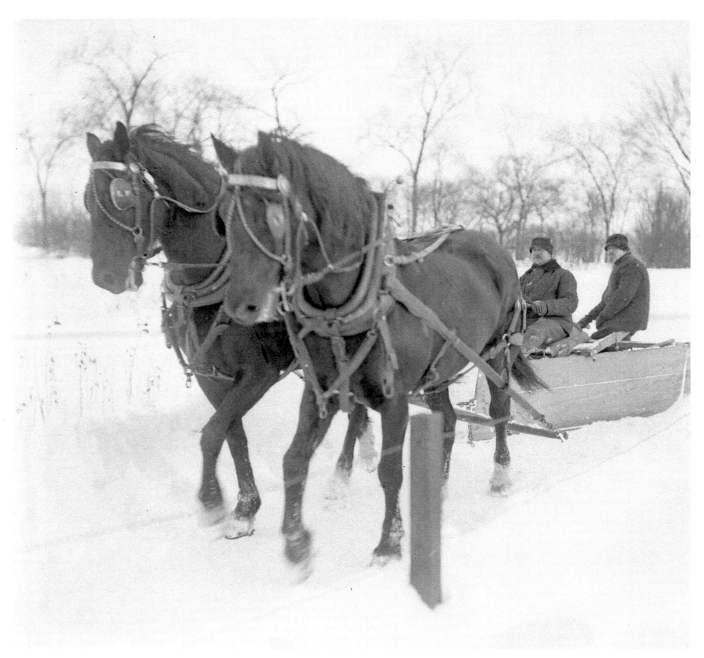

A two-horse team pulls men on a snowplow in Lincoln Park, around 1903.

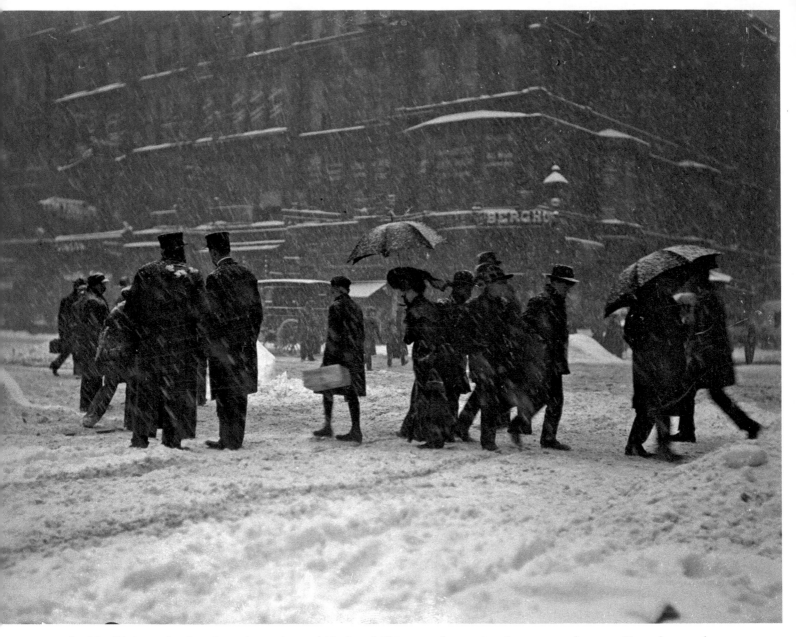

A white Christmas has long been the sentimental ideal, and Chicagoans have enjoyed many over the years. Here, shoppers brave a storm around 1905.

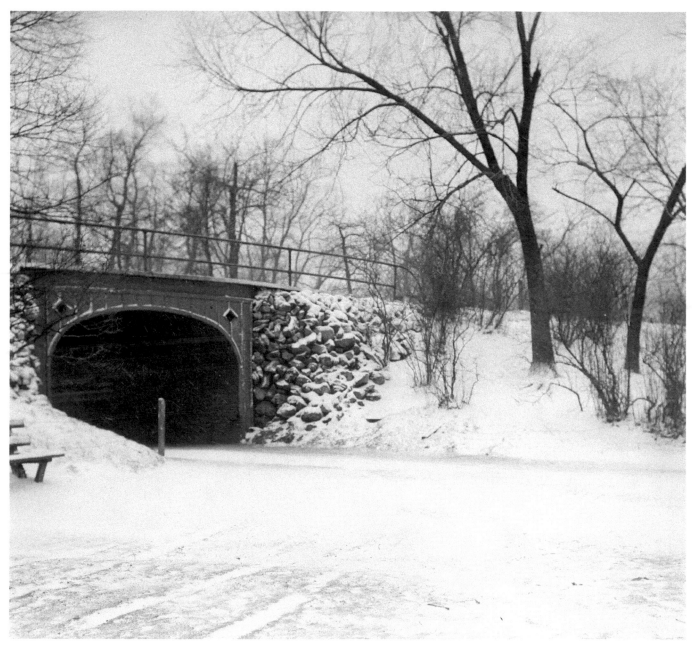

Snow-covered paths near a pedestrian tunnel in Lincoln Park, 1903.

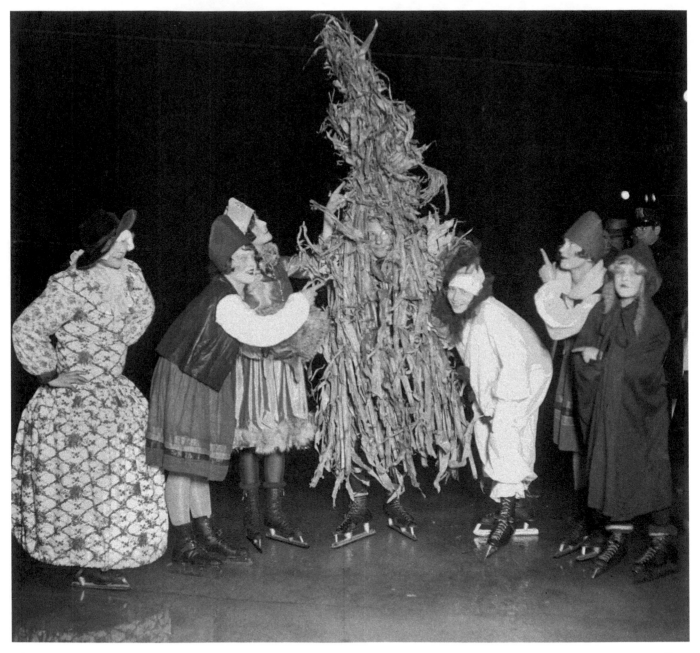

Children wearing skates and costumes pose on the ice at the Chicago Daily News Ice Carnival. The "tree" in the center is actually a child in costume.

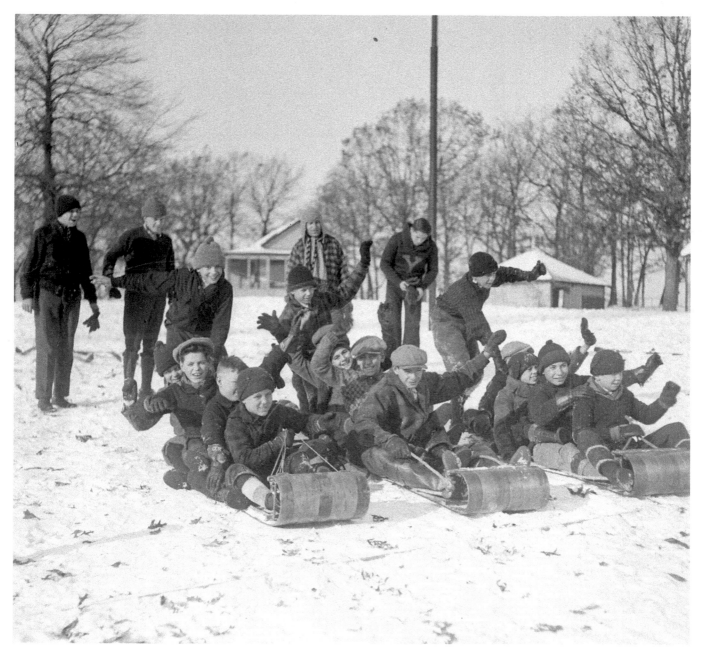

Children get set for a toboggan race, around 1927.

Christmas lighting at the Board of Trade, 1935.

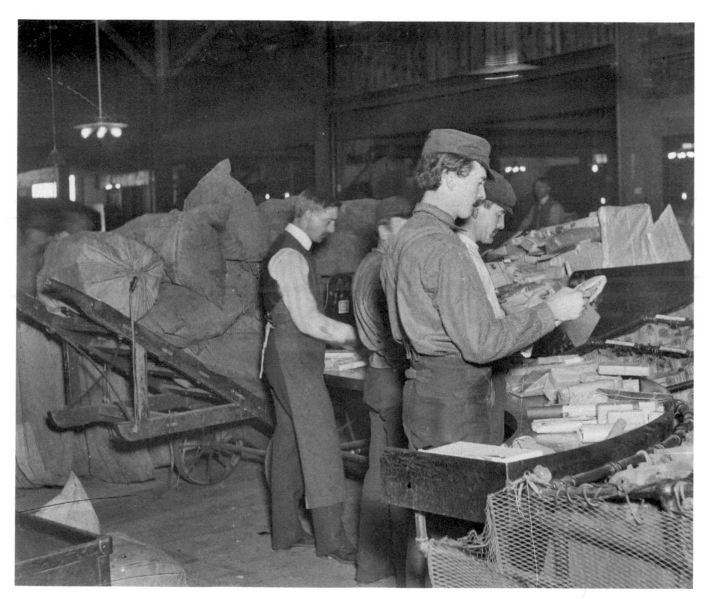

Postal workers sort through an abundance of holiday mail.

N. Sorenson delivers mail through the snow to Florence Webb.

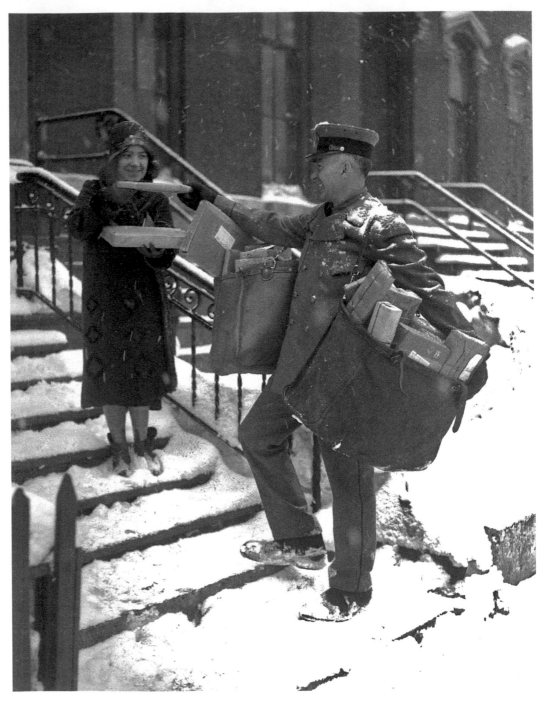

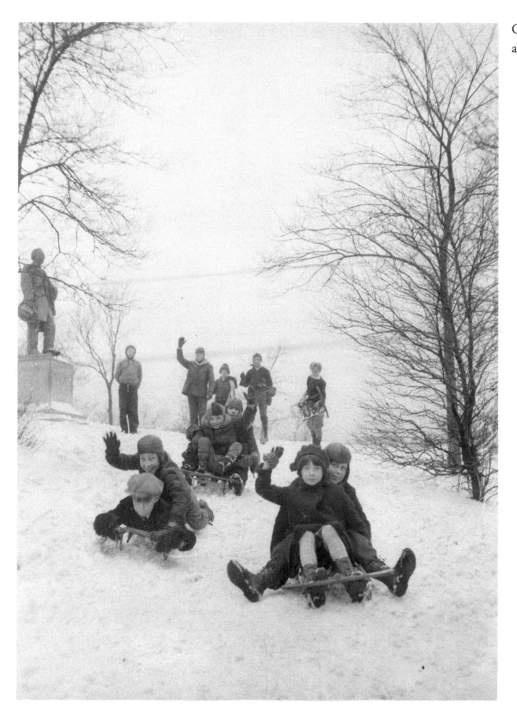

Children wave as they sled through a snowy Lincoln Park, 1929.

A little girl poses proudly with her snowman.

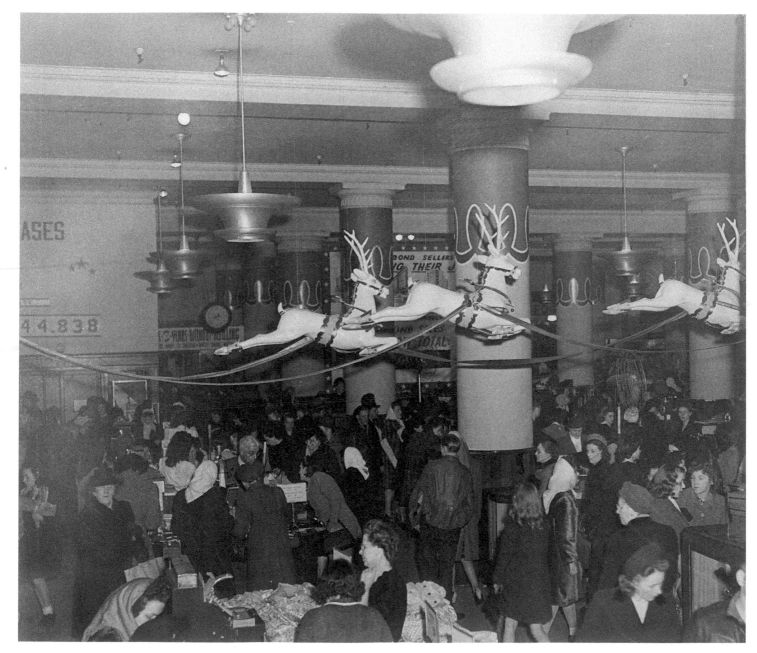

Christmas shoppers look for bargains during World War II, around 1944.

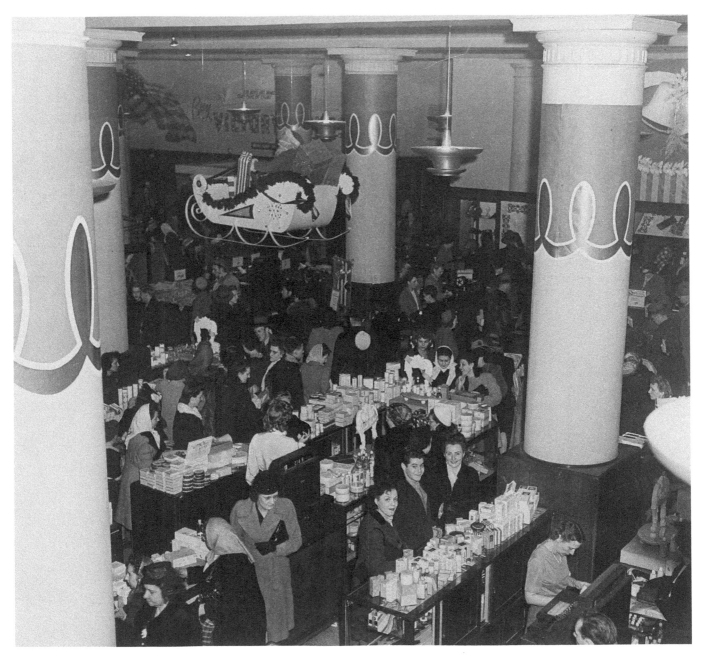

Signs around the store encourage Chicagoans to buy Victory Bonds.

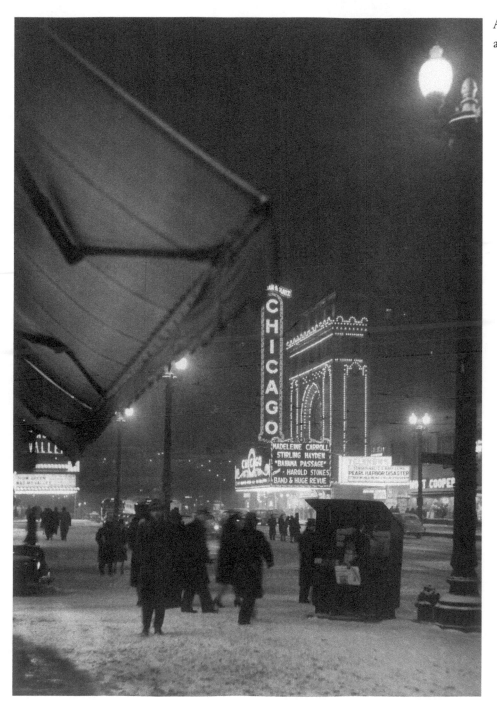

A winter scene in the Loop near State and Randolph streets, 1942.

Lighted stars adorn the Water Tower and the Palmolive Building.

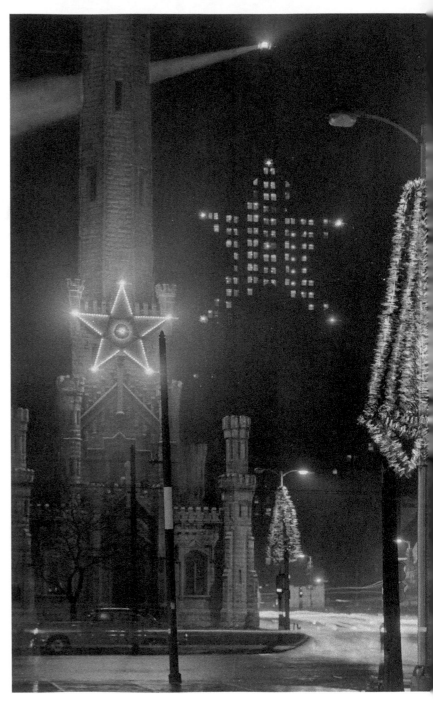

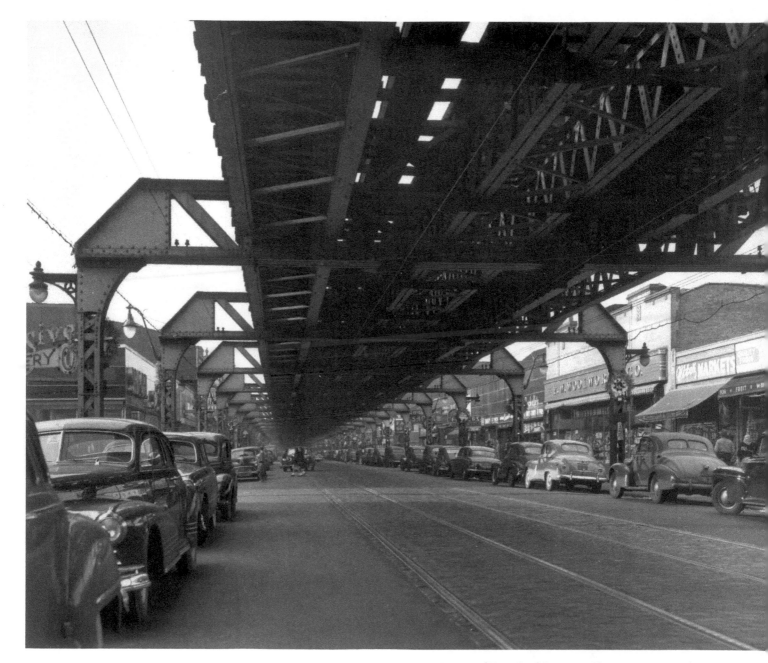

A view of East 63rd Street at Christmastime, 1948.

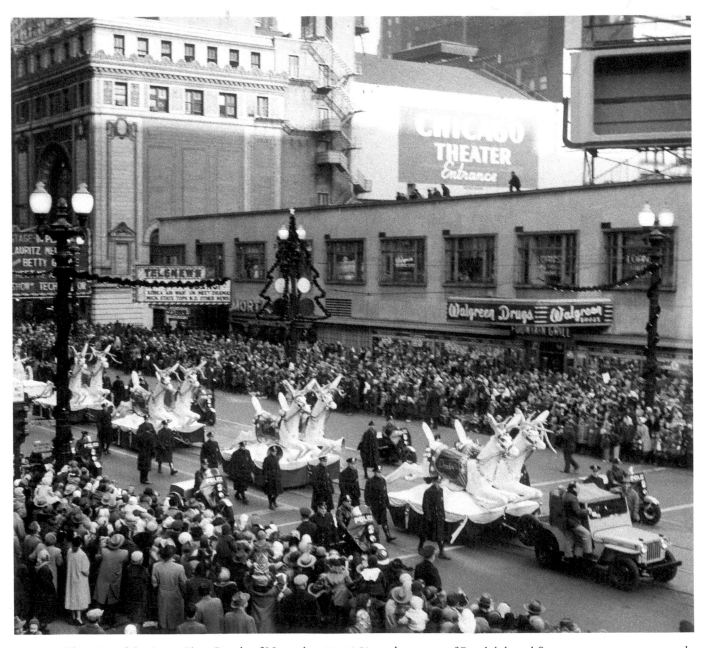

This view of the Santa Claus Parade of November 17, 1951, at the corner of Randolph and State streets, captures not only the Christmas spirit, but some Chicago icons as well. To the left, the Chicago Theater marquee towers over the street, while a Walgreens store appears at right.

The Italian Court Building on Michigan Avenue is decorated for Christmas with evergreen trees, around 1955.

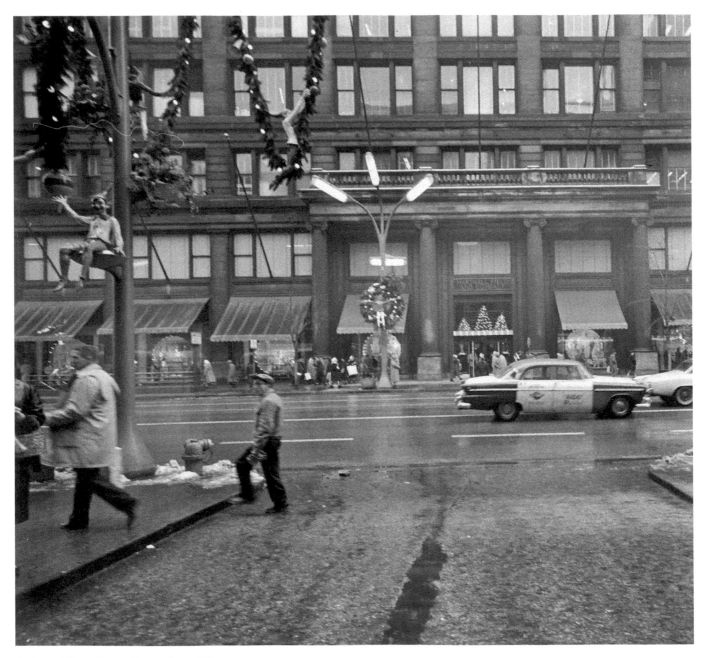

A view of State Street, December 1959.

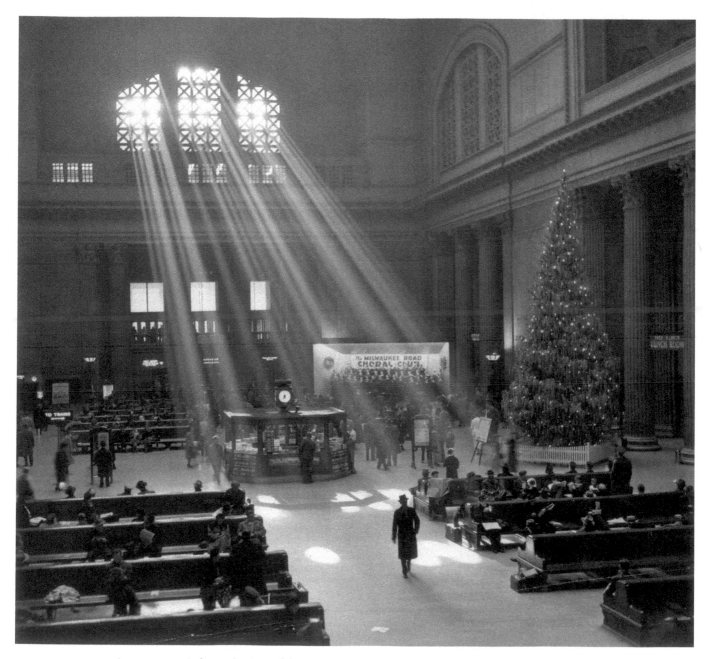

A dramatic view of the waiting room at Union Station during the Christmas season, around 1952.

The Palmolive Building at night with lights cascading from the beacon at the top.

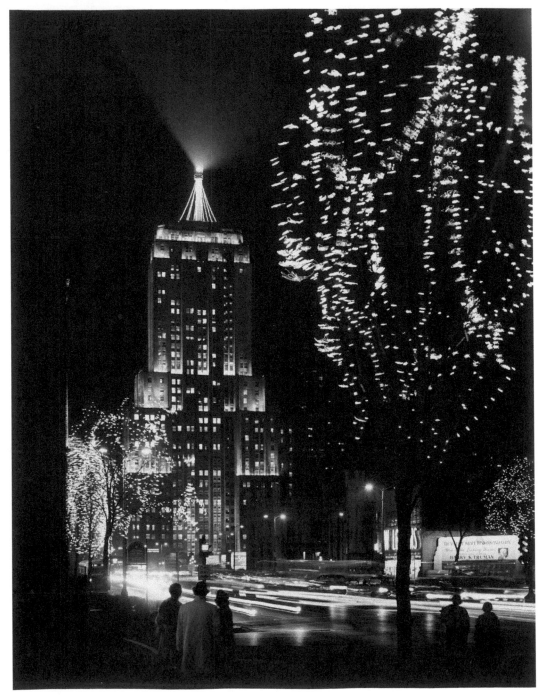

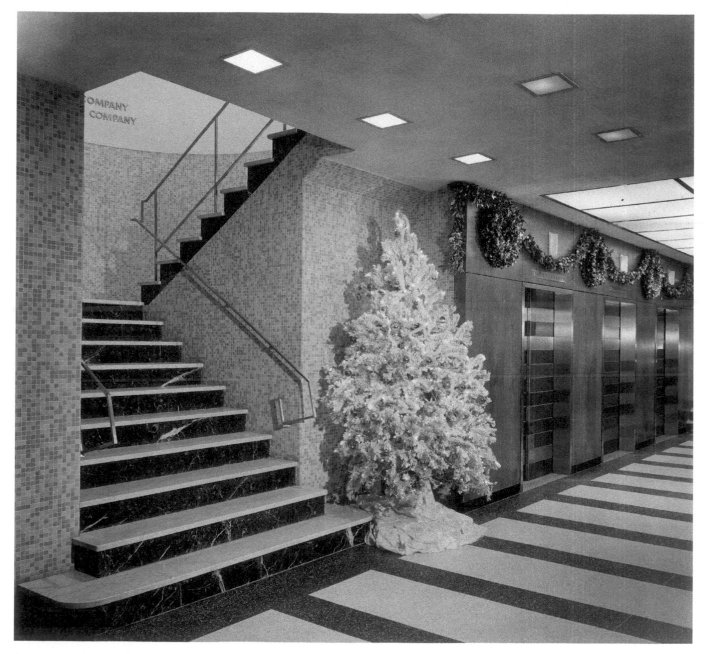

In postwar Chicago, different styles of Christmas decorations emerged, such as this white artificial Christmas tree that adorns the lobby of an office building.

A view of the official city Christmas tree, the year not identified.

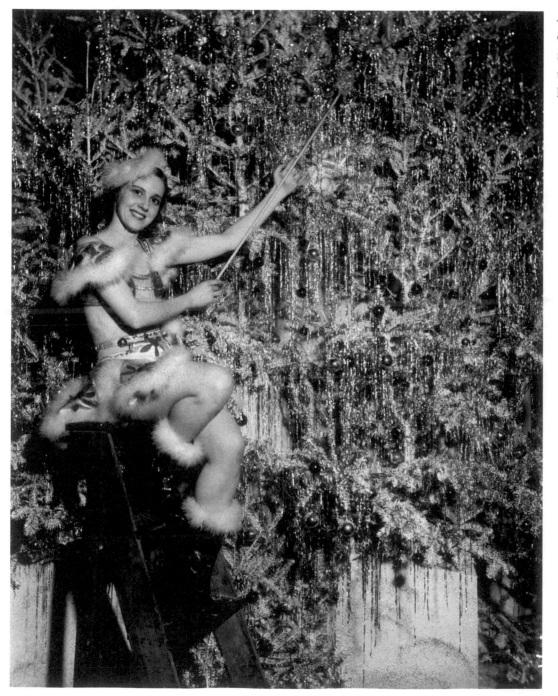

An undated, less conventional view of the municipal Christmas tree, with a young hostess in furry costume.

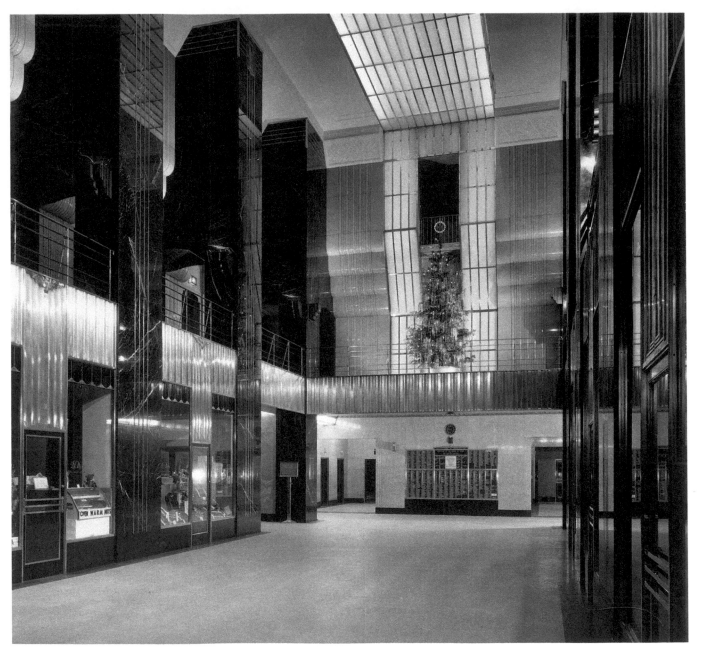

Interior view of the lobby of the Board of Trade Building, featuring a Christmas tree.

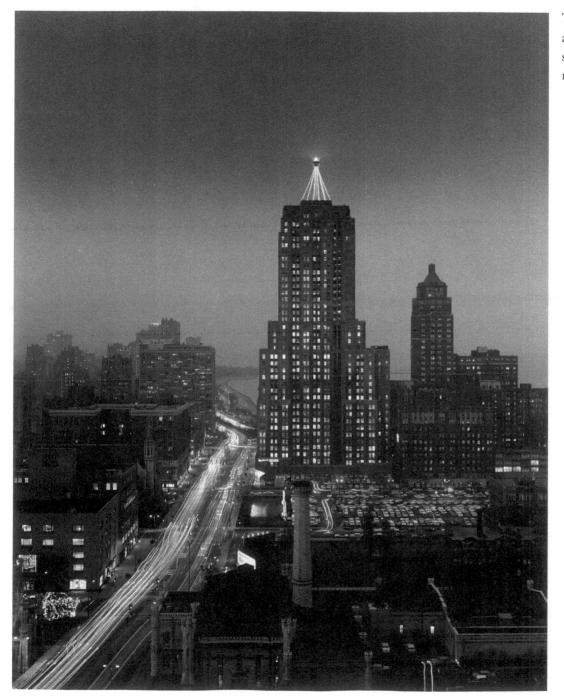

The Palmolive Building around Christmastime, silhouetted against the night sky.

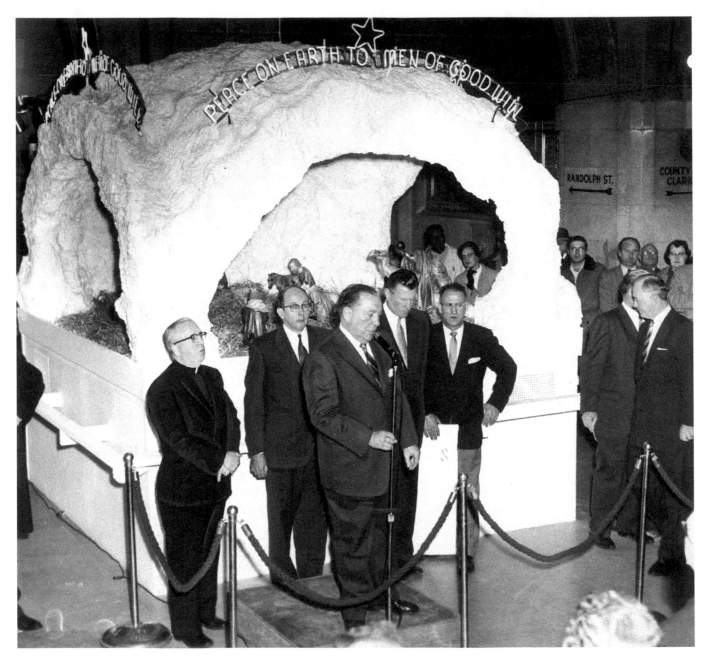

In addition to its secular decorations, the city has long presented a crèche scene. Mayor Richard J. Daley dedicates the Christmas manger with city, state, labor, business, and religious officials at City Hall.

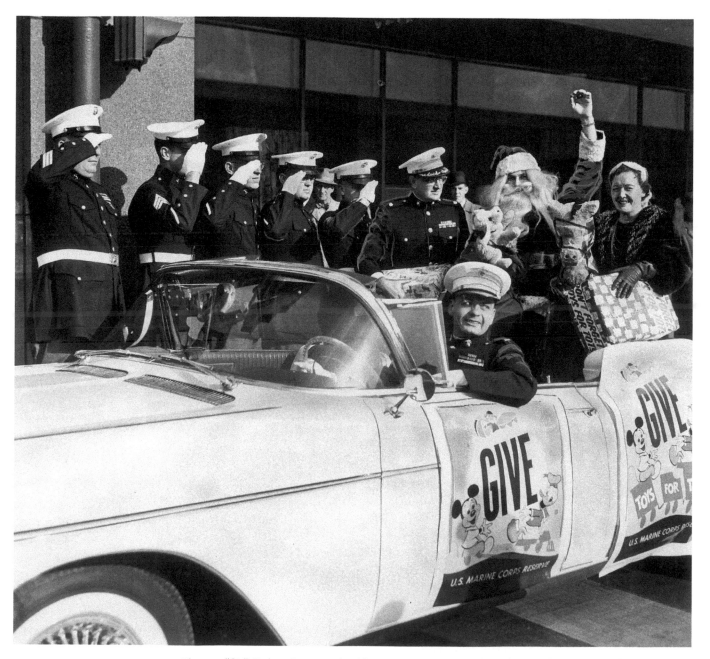

Eleanor "Sis" Daley, the mayor's wife, joins Santa in spreading the word about Toys for Tots, 1957.

Mayor and Mrs.
Daley help kick
off the Toys for
Tots campaign
of 1958.

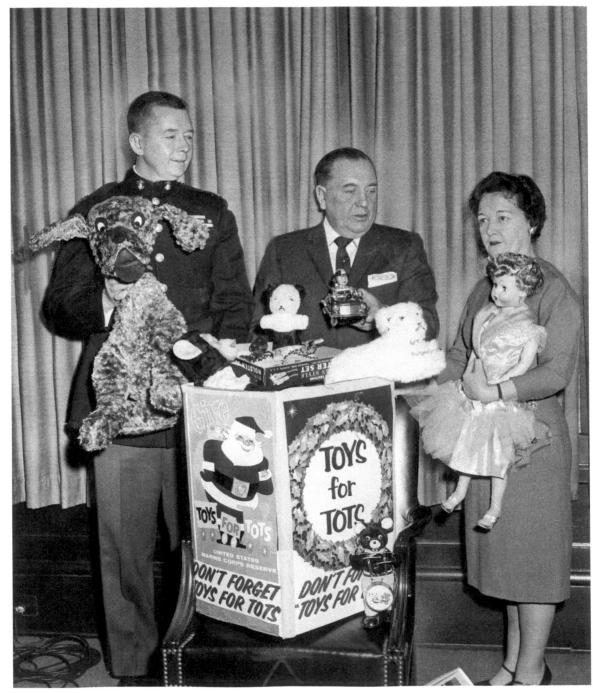

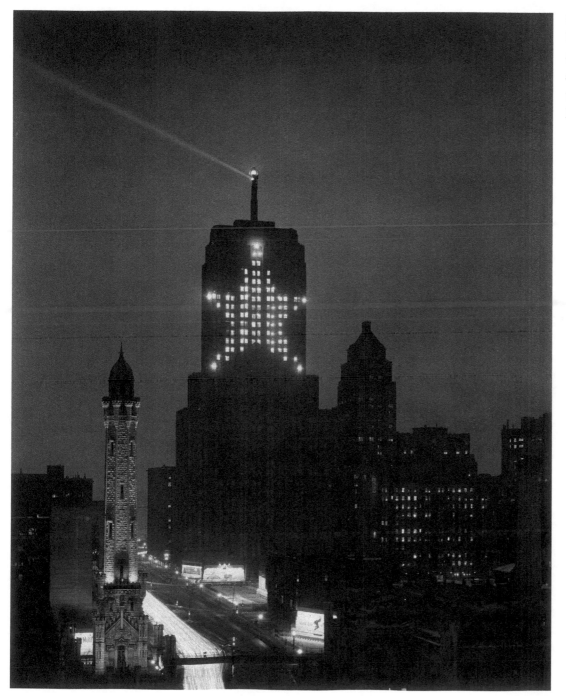

One of the city's iconic buildings, Palmolive, displays a Christmas star along with its trademark beacon light.

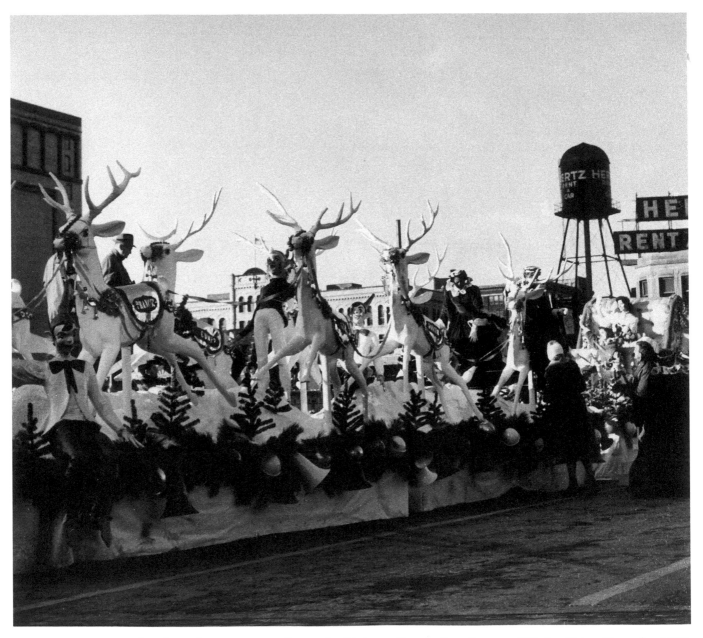

Santa's reindeer appear on a float at the Christmas Parade, State Street and Wacker Drive, November 1959. Clement C. Moore named the magical creatures who flew Santa's sleigh around the world in his poem "A Visit from St. Nicholas," published in 1823.

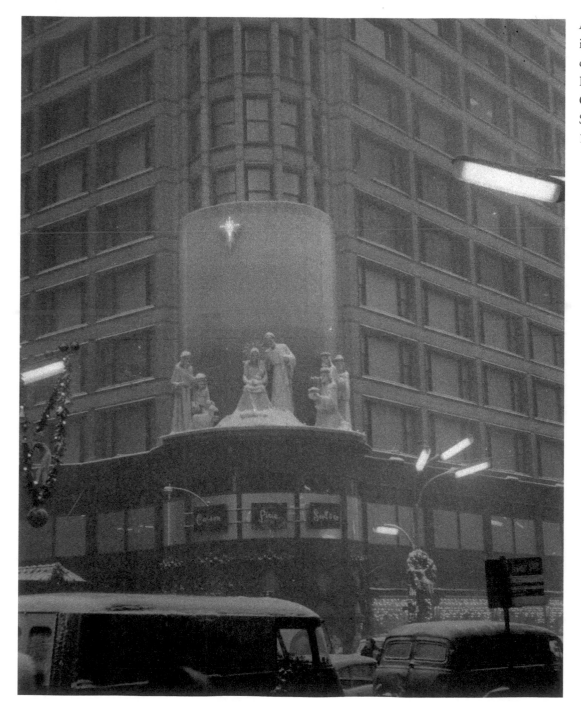

A crèche scene installed above the entrance of Carson Pirie Scott and Company on State Street, December 19, 1959.

Christmas tree at the Eisenhower Expressway, January 1, 1960.

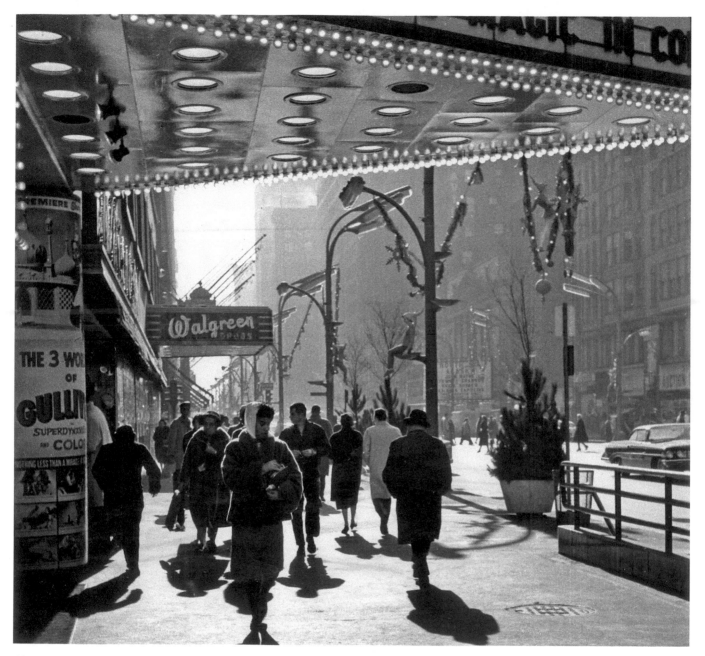

Christmas Eve 1960, on State Street near Randolph. The entrance to the Chicago Theater is in the foreground.

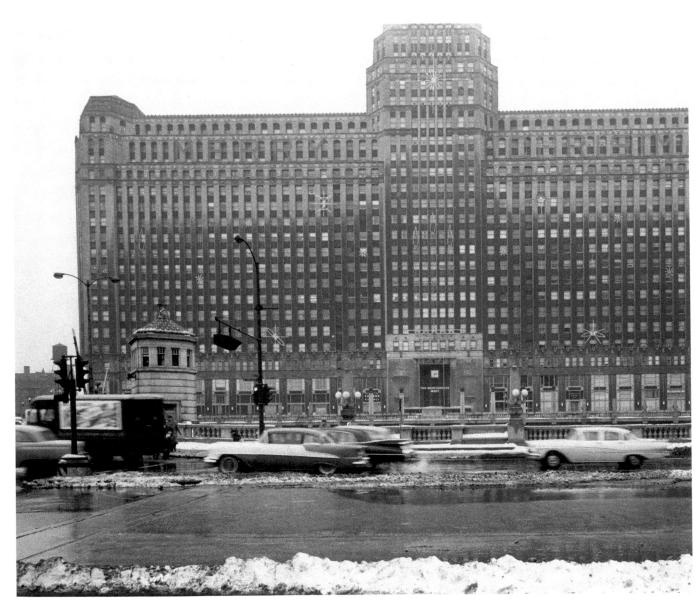

The Merchandise Mart during the day at holiday time.

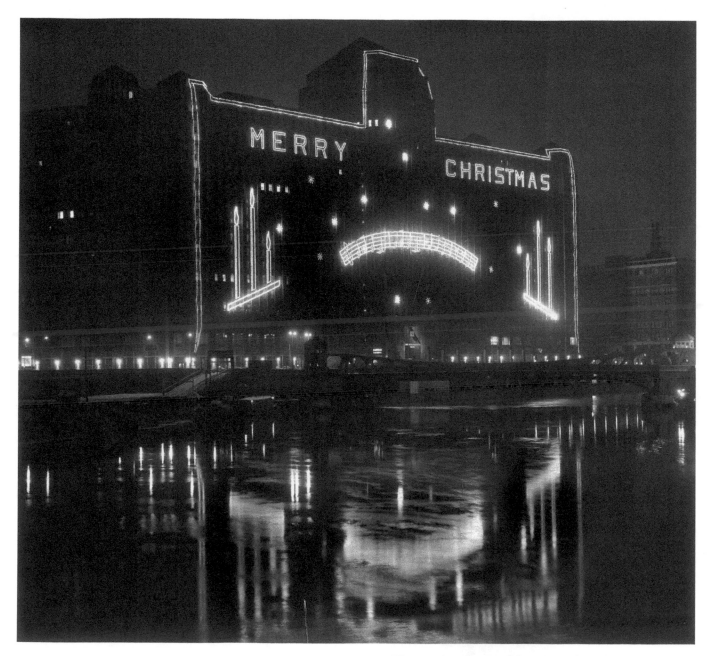

The Merchandise Mart at night with its dramatic lighting.

Admiring Chicago's
Christmas tree
at Congress and
Michigan, January 1,
1960.

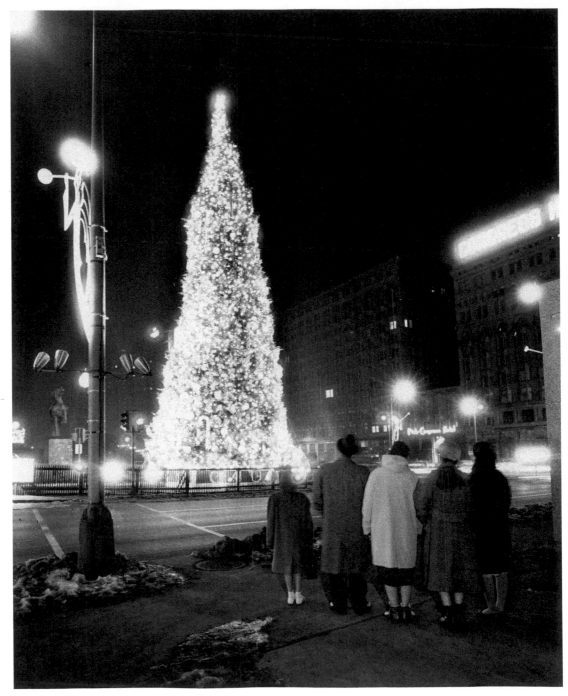

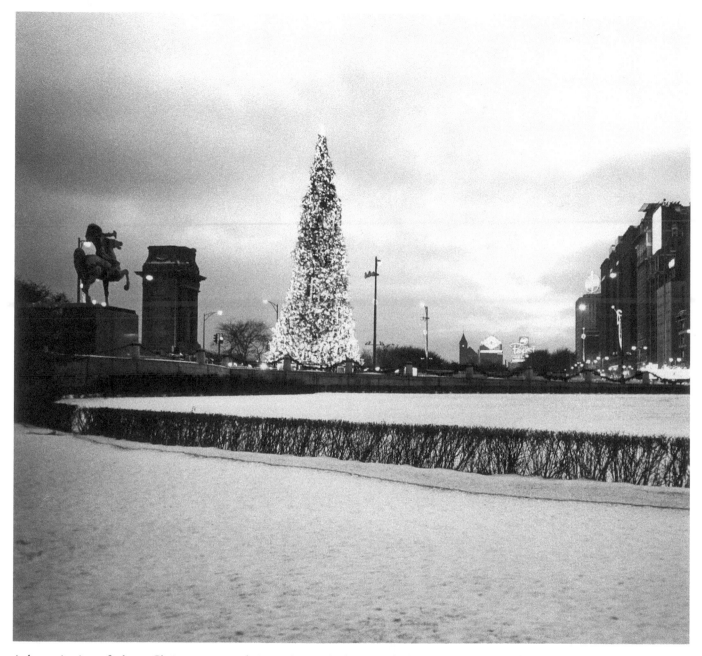

A dramatic view of a huge Christmas tree and city sculpture, looking south along Congress, east of Michigan, December 26, 1960.

State Street decorated at night, with a view of the Charles A. Stevens building.

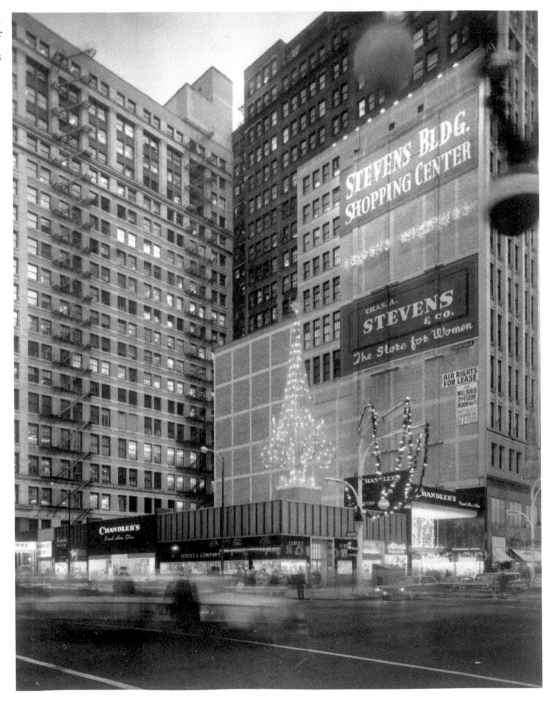

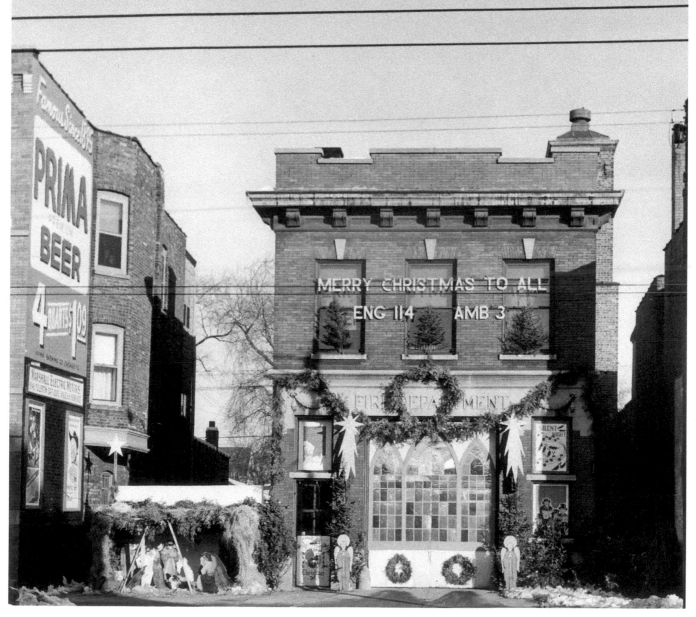

Firehouse of Engine Company No. 114 and Ambulance Company No. 3 on Fullerton Avenue is decorated for Christmas, December 1961.

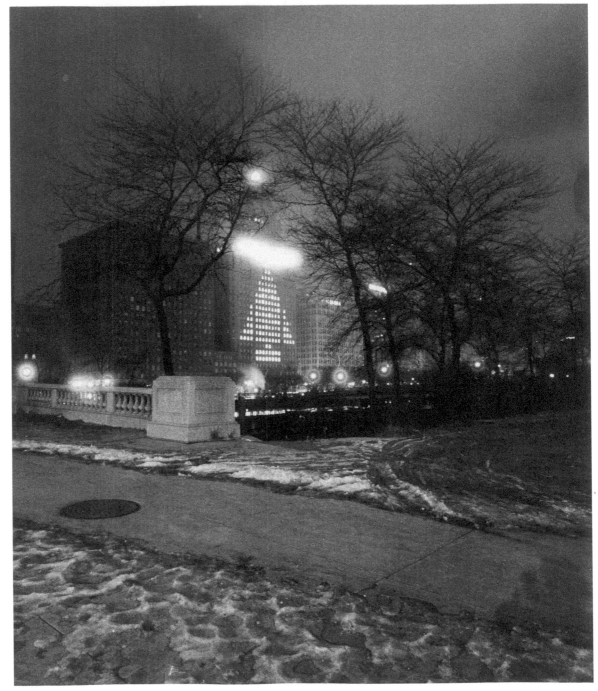

The People's Gas Building is decorated for the holidays, January 1, 1961.

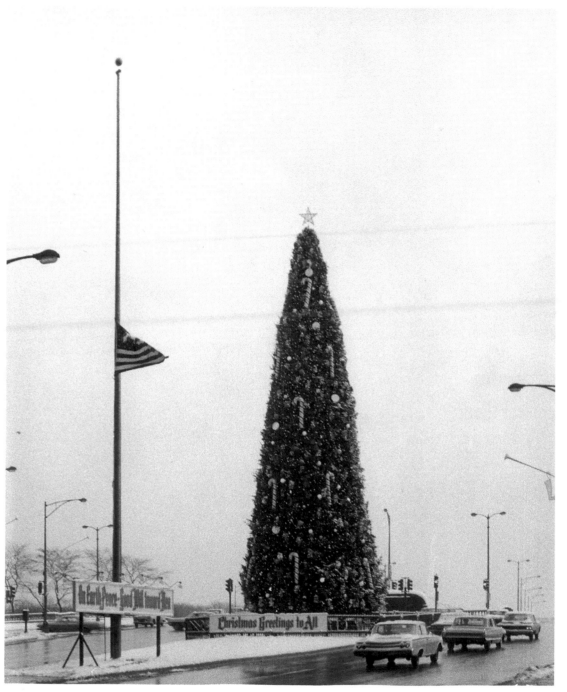

In December 1963, a decorated Christmas tree sits poignantly next to a flag at half-staff in honor of John F. Kennedy, who had died less than a month earlier.

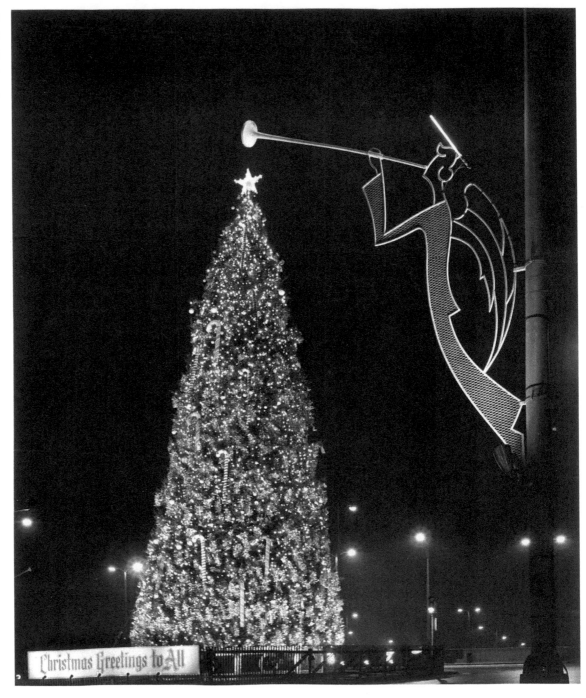

Chicago's Christmas Tree at Congress Street Plaza, December 1963.

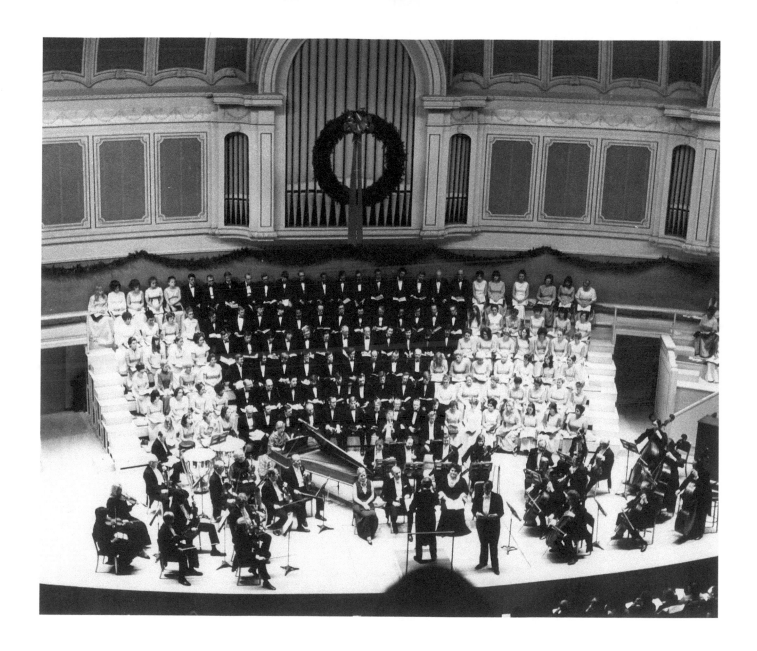

The Apollo Chorus of Chicago in a Christmas performance.

An elf sits cheerfully waving above State Street on December 23, 1964.

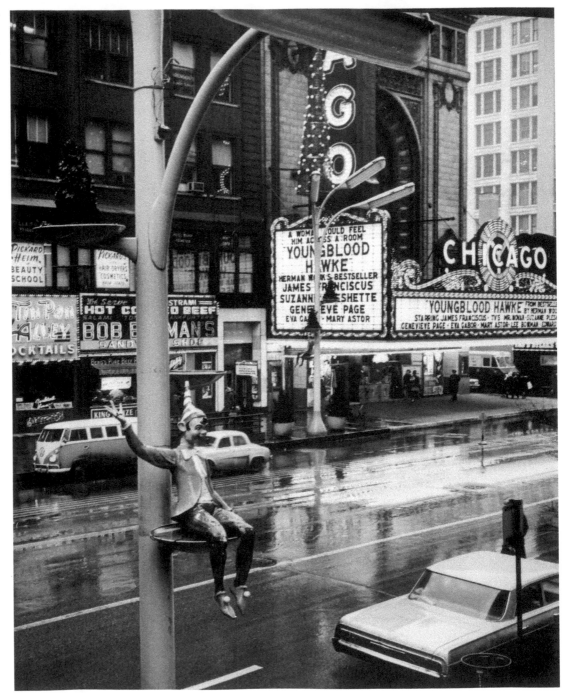

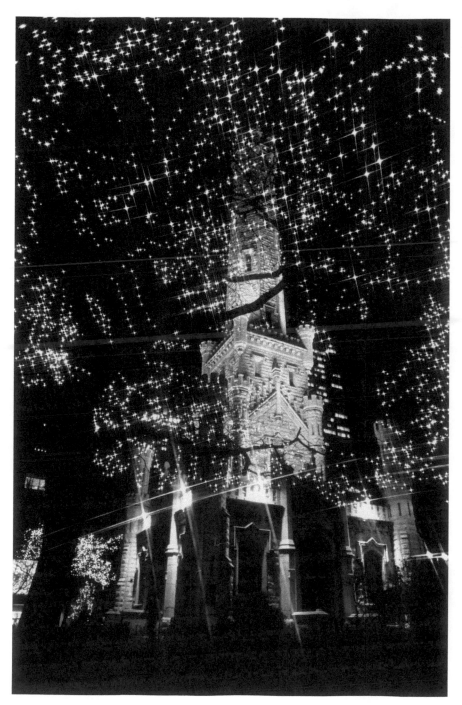

The Water Tower surrounded by Christmas lights in 1967. As one of the few buildings to survive the Great Fire of 1871, it was an important landmark in the days after disaster and today remains a familiar and popular attraction.

The Water Tower's
neighborhood is lit to
festive effect for the
holidays in 1972.

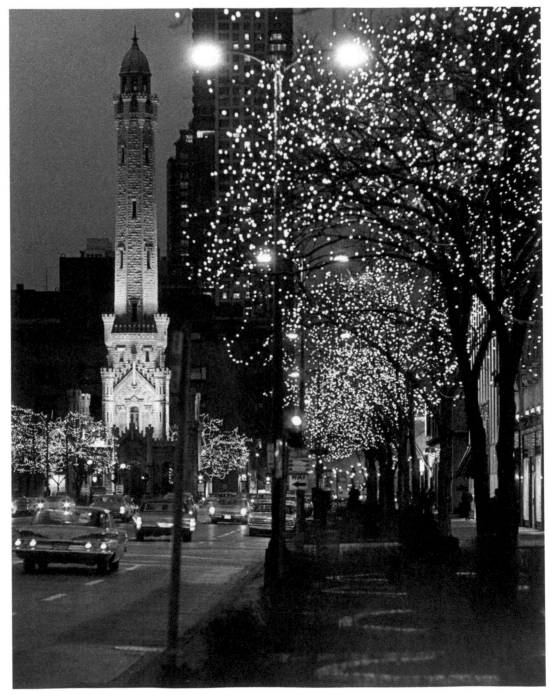

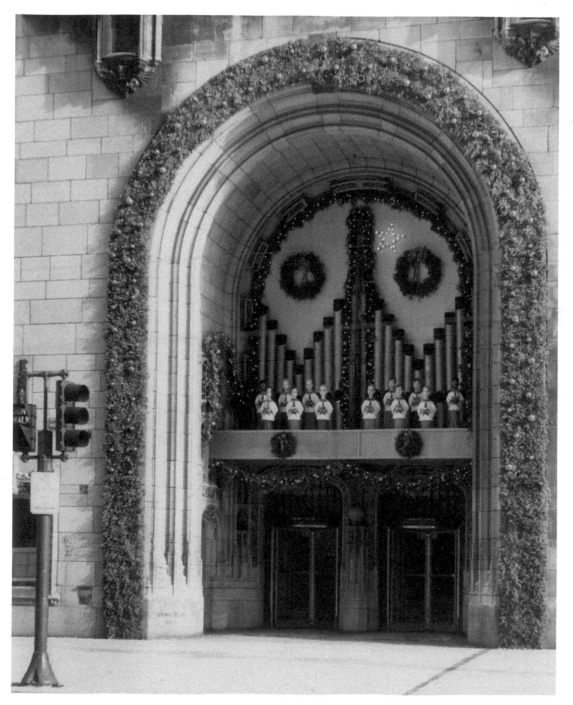

The Tribune Tower's neo-Gothic facade provides the perfect backdrop for Christmas decorations, December 1968.

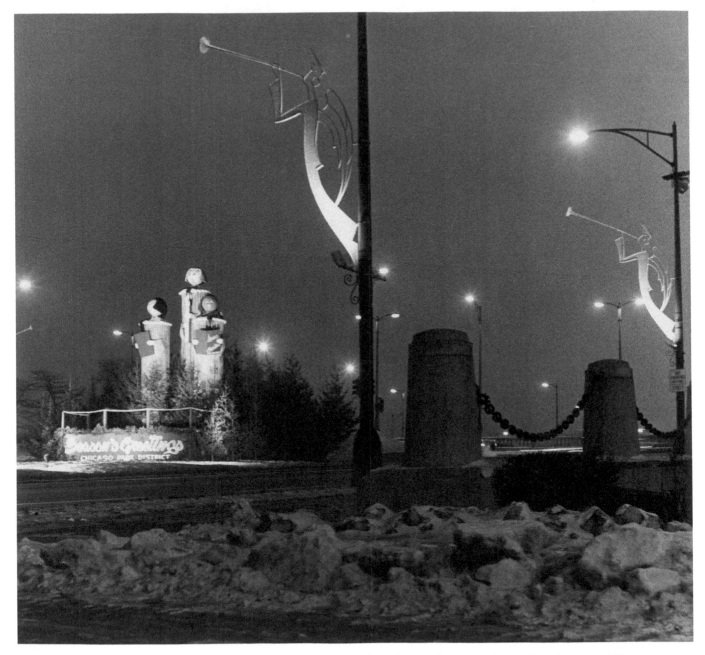

A Chicago Park District display at Congress Plaza features a choir of angels extending season's greetings, January 1969.

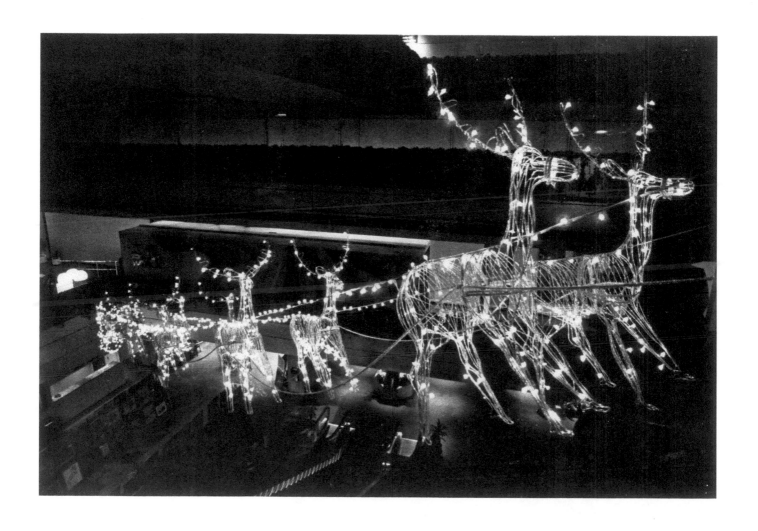

The Hyatt Regency O'Hare boasted a 60-foot-long, 13-foot-tall, steel-and-wire sculpture of Santa's sleigh and reindeer, covered with more than 5,000 Italian lights.

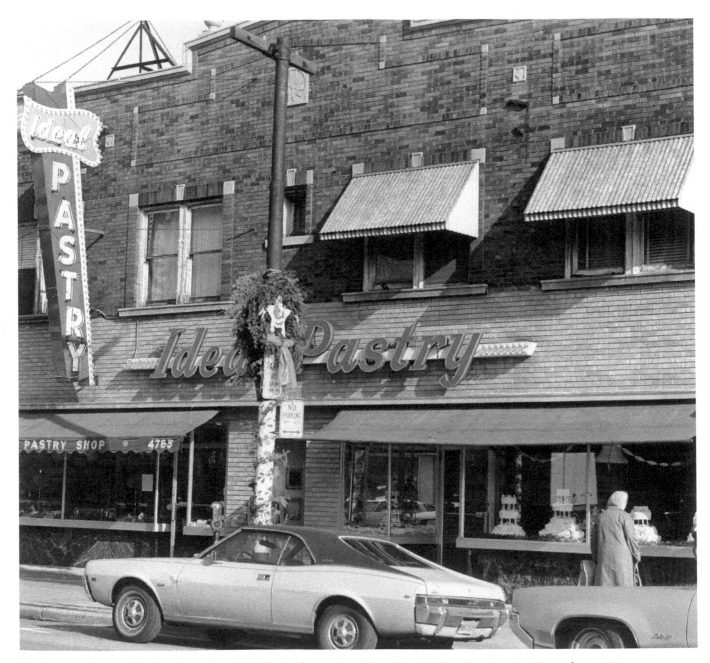

Christmas in the neighborhoods: a view of the festive decorations along North Milwaukee Avenue, December 1973.

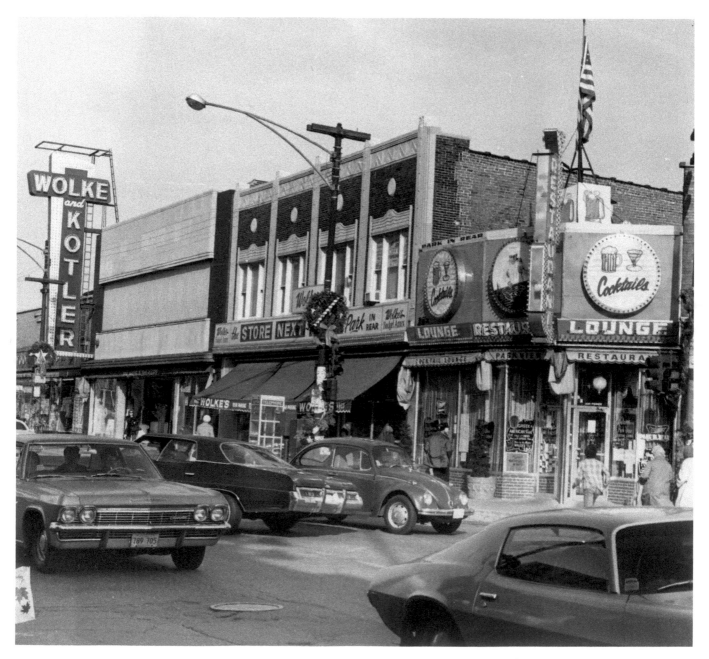

Milwaukee Avenue, Christmastime 1973.

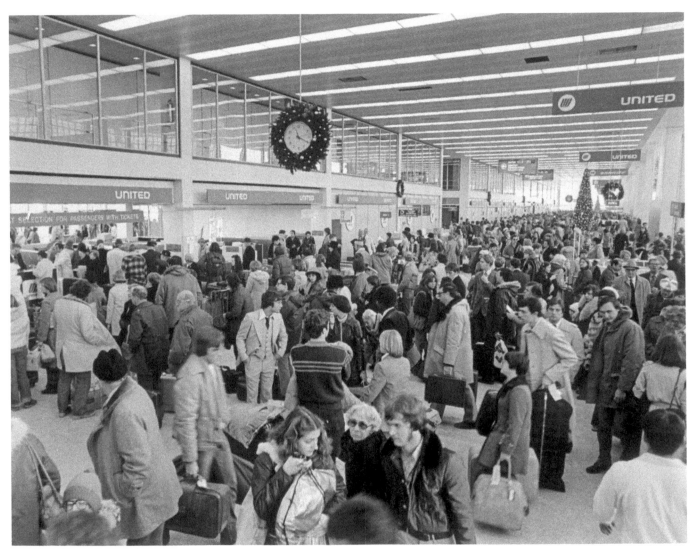

The United Airlines check-in counters at O'Hare, about 1978, swarm with a crowd of holiday travelers. Christmas decorations, including the wreath around the clock near the top and lighted trees in the background, add some festive touches.

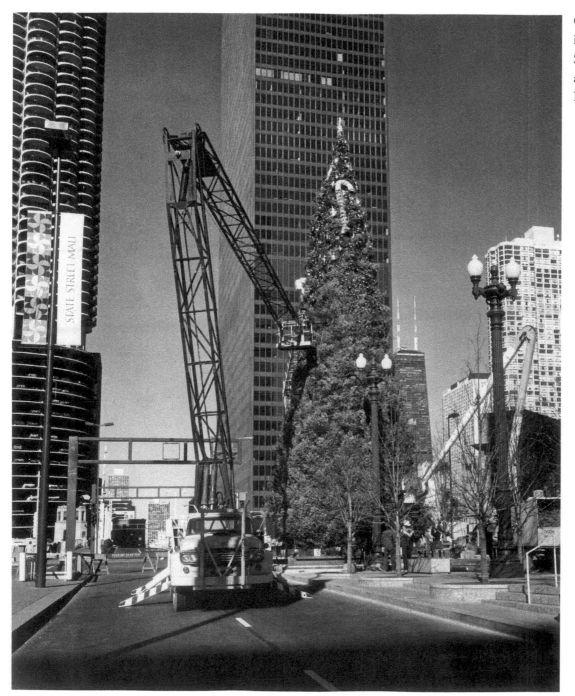

Christmas tree
installation on the
State Street Mall
at Wacker Drive,
November 17, 1981.

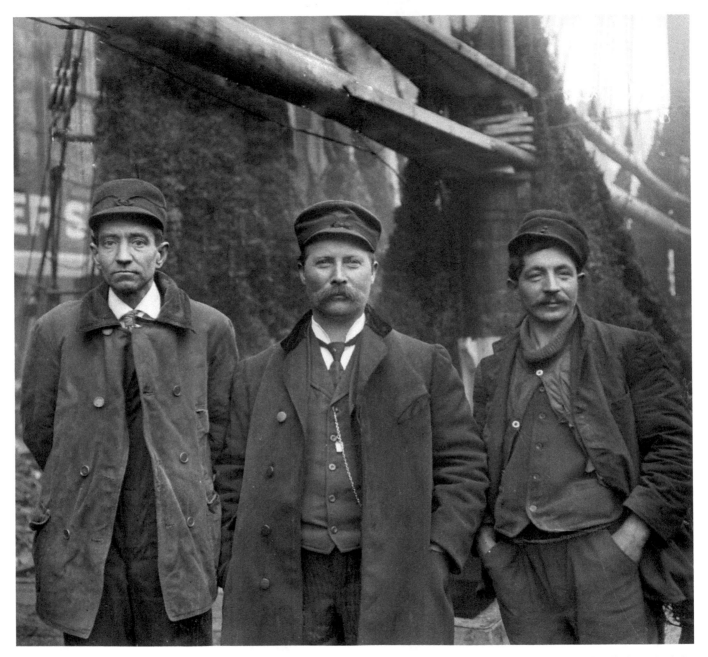

For many Chicagoans in the early 1900s, Captain Herman "Christmas Tree" Schuenemann, at center, officially launched the holiday season when he docked his ship, the *Rouse Simmons,* full of evergreens from Upper Michigan, at the Clark Street Bridge.

O Christmas Tree

An Evergreen Tradition

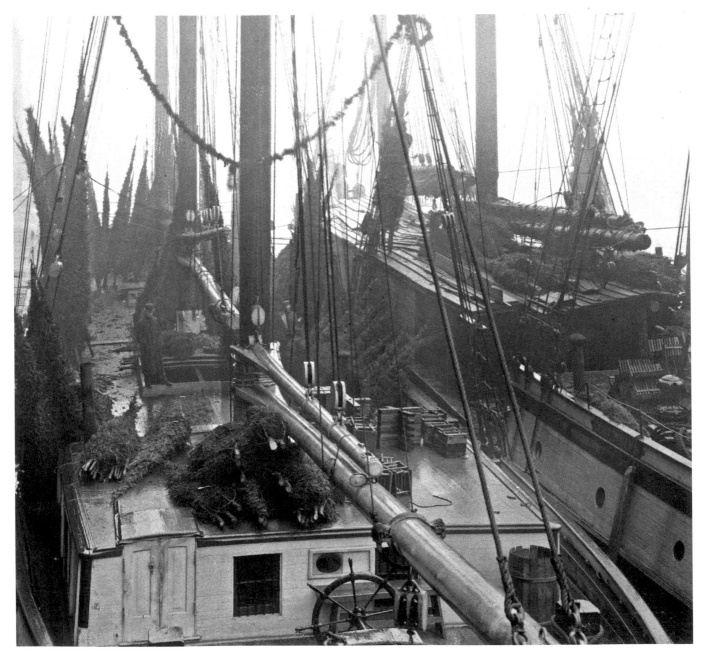

The *Rouse Simmons* docked on the Chicago River. Although not the only ship that transported trees, it was the most famous, and newspapers referred to it as the "Santa Claus Ship."

A view of Christmas trees and wooden crates on South Water Street in the Loop, 1909.

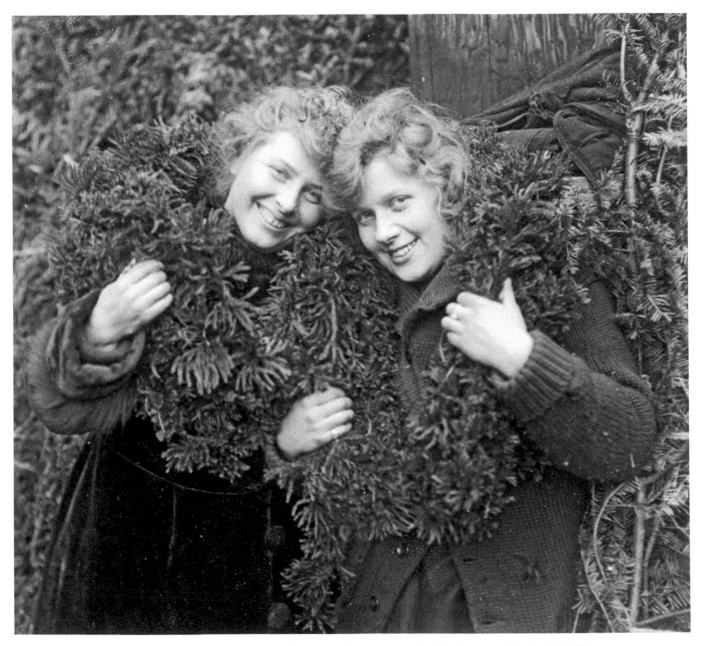

The twin sisters Hazel and Pearl Schuenemann, seen here around 1917, were familiar faces at their family's Christmas tree business, which their mother continued after the captain's death in a shipwreck in 1912.

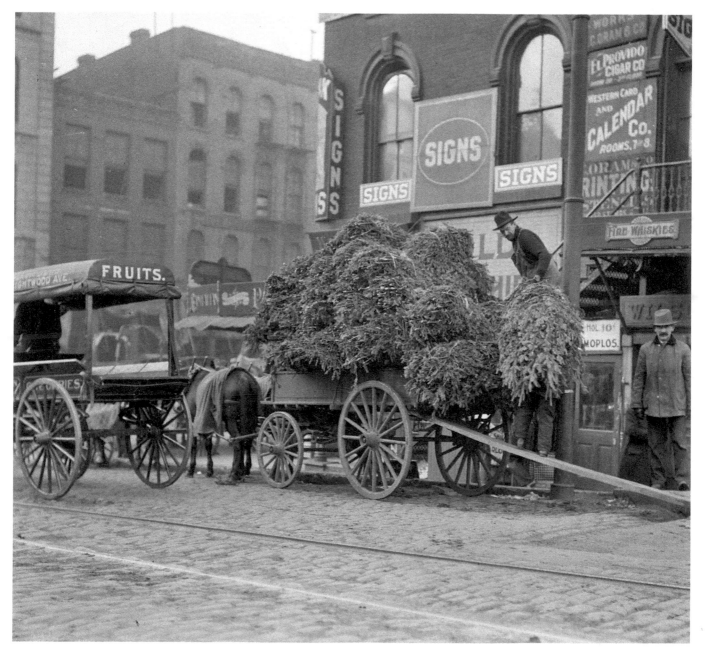

A man unloads evergreen trees from a wagon, around 1904. German immigrants are credited with bringing to America the custom of decorating trees for Christmas.

A young woman poses with her cat and a Christmas tree, lit with real candles, in December 1913. The trees shipped from Upper Michigan ended up in homes like this one.

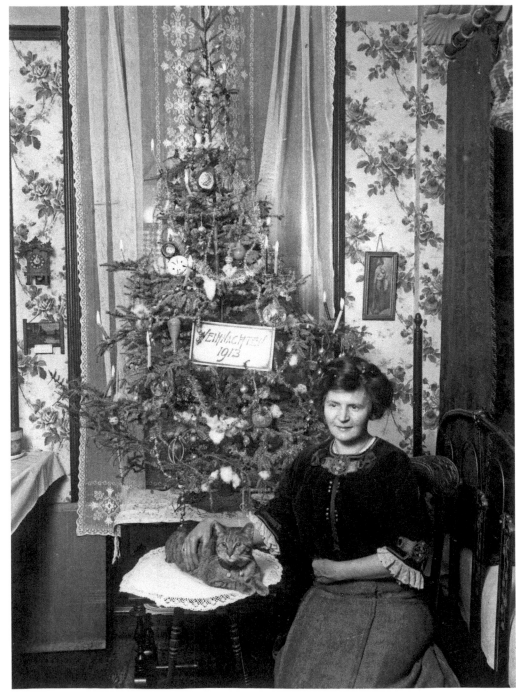

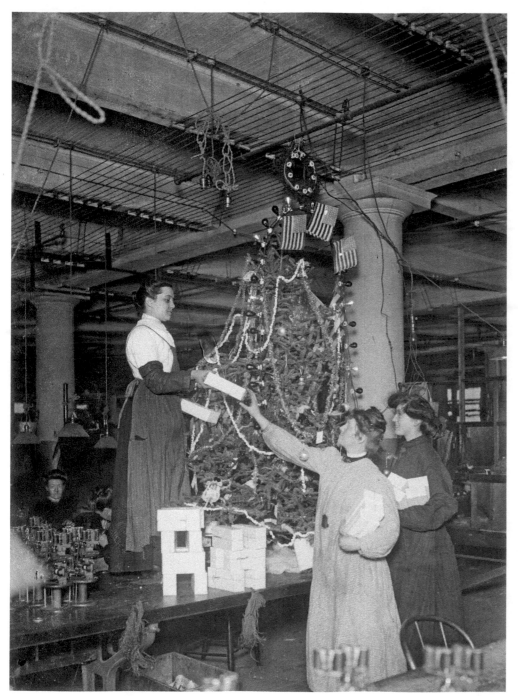

Women decorate a tree in a factory.

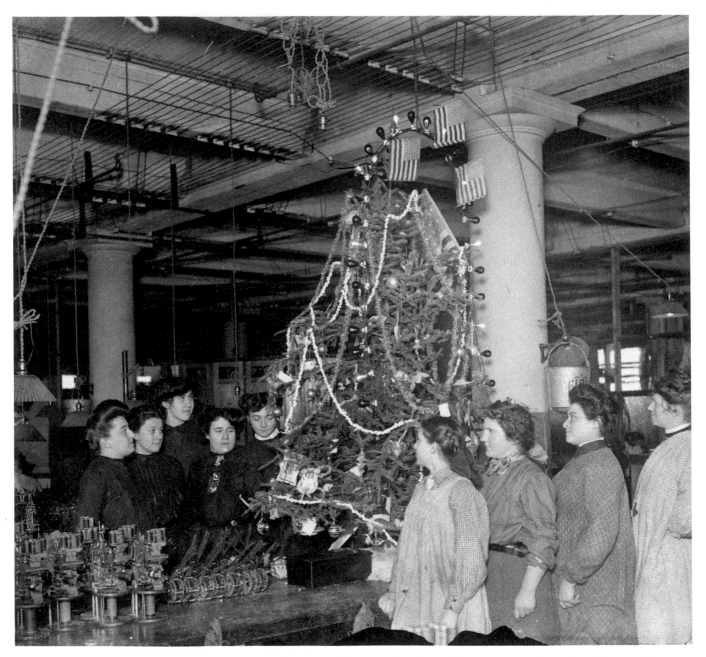

Women gather around the completed tree. Three American flags adorn the top of the tree.

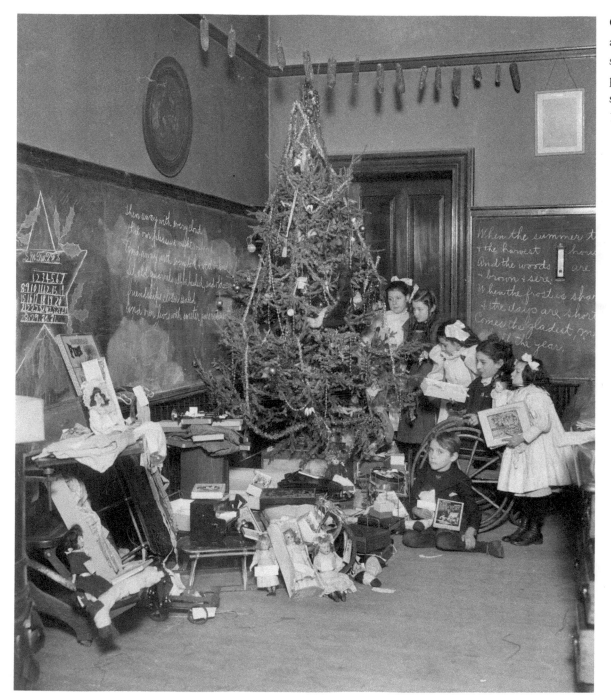

Children gather around a tree surrounded by presents in a schoolroom in 1905.

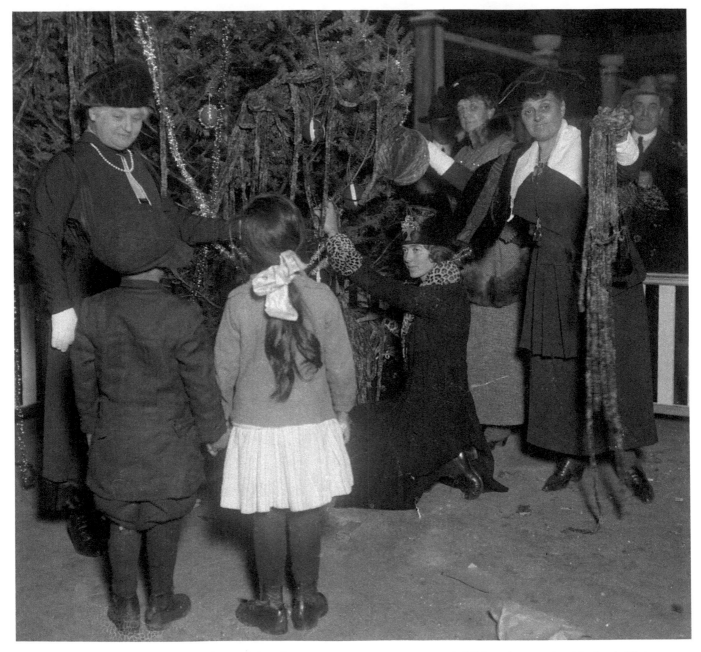

Chicagoan Gusta Rothschild, at far left, stands beside a Christmas tree as women and children decorate it with tinsel, Christmas 1917.

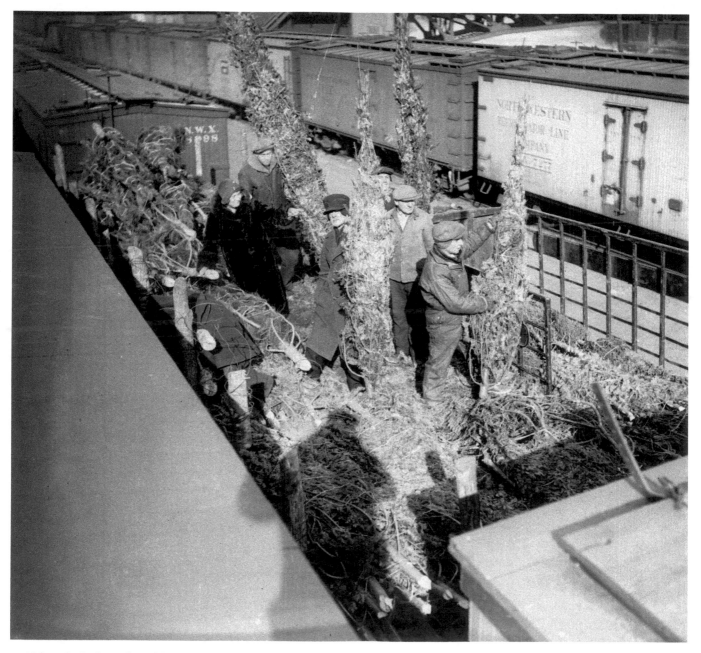

Although the legends and lore of the Christmas tree ships have inspired songs and plays, trees arrived in the city by more prosaic methods as well. Here in 1929, a woman and several men stand on top of a pile of Christmas trees recently delivered by train.

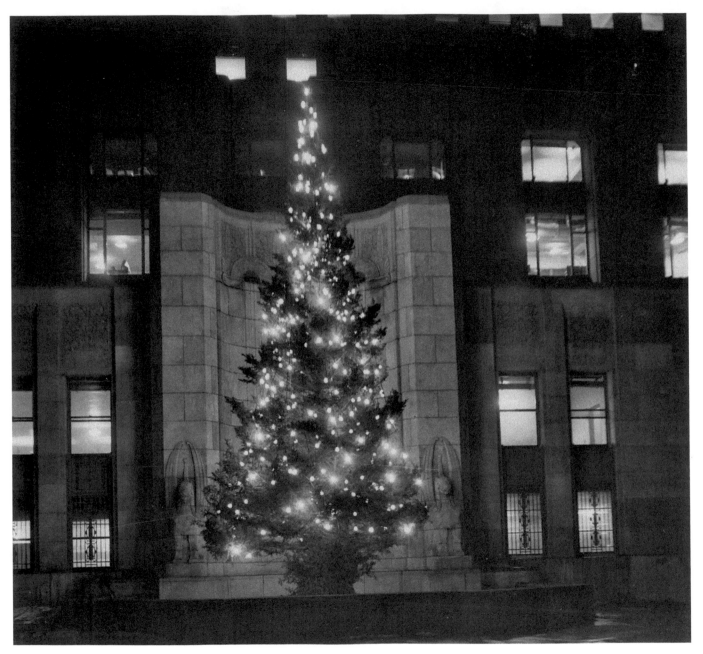

A lighted Christmas tree outside the Daily News Building, 1929.

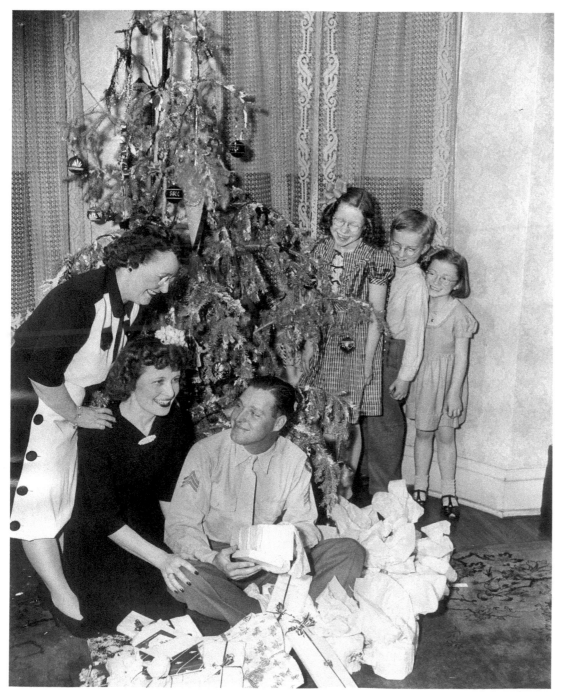

A young soldier surrounded by his family opens a gift—three months after Christmas. Sergeant Oliver Minder was unable to make it home for the holidays in December, so his family kept the tree trimmed and the presents wrapped until he could join them in March 1945.

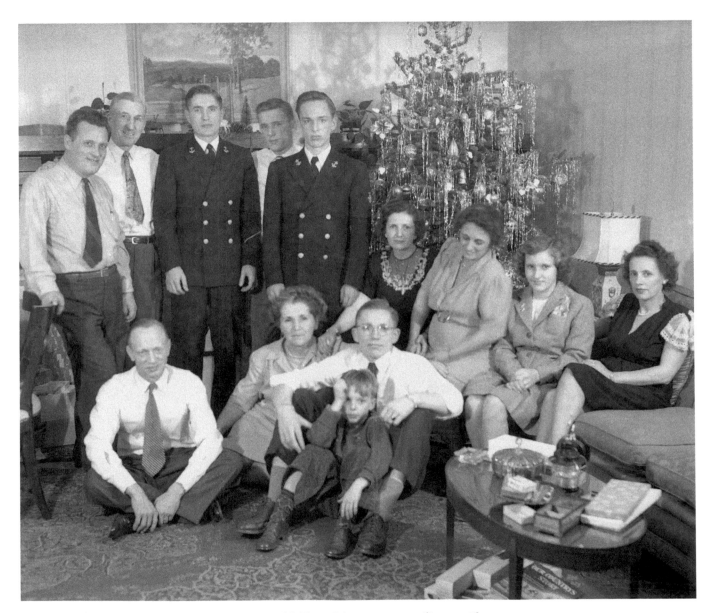

A family gathers in front of the Christmas tree, 1946. Two of the men wear military uniforms.

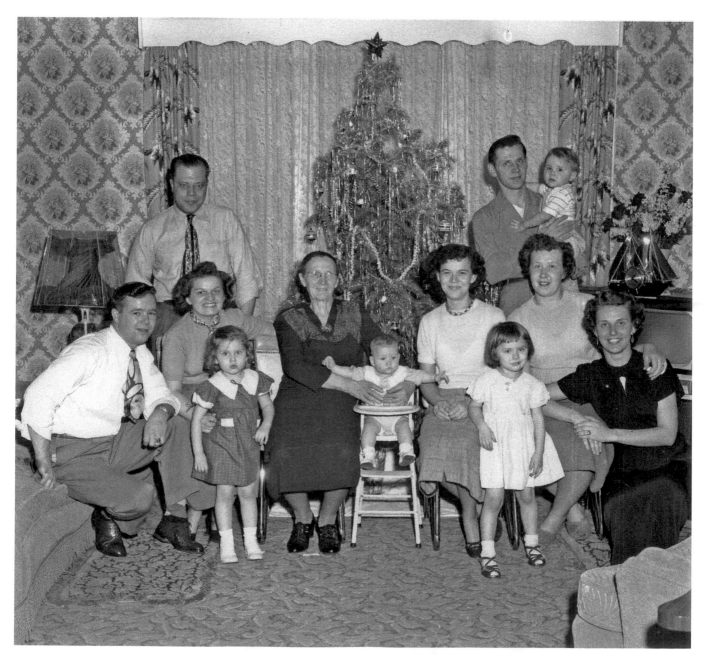

A multigenerational family gathering, December 1950.

A Christmas card portrait featuring Christmas cards, 1953. The earliest American Christmas cards were made in the 1850s.

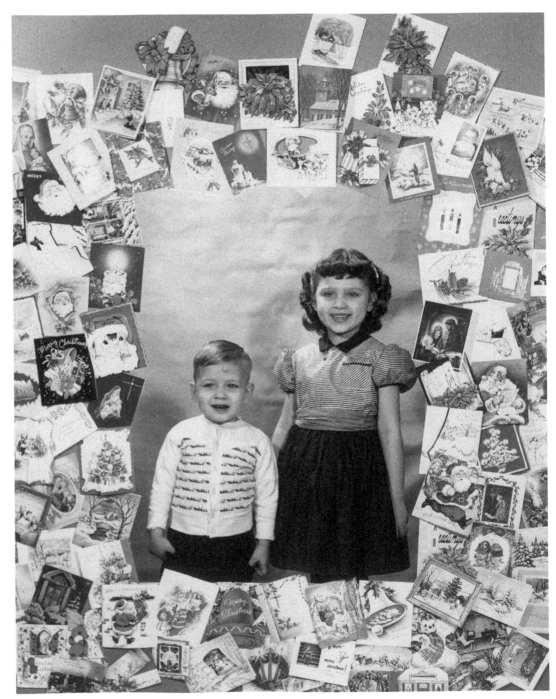

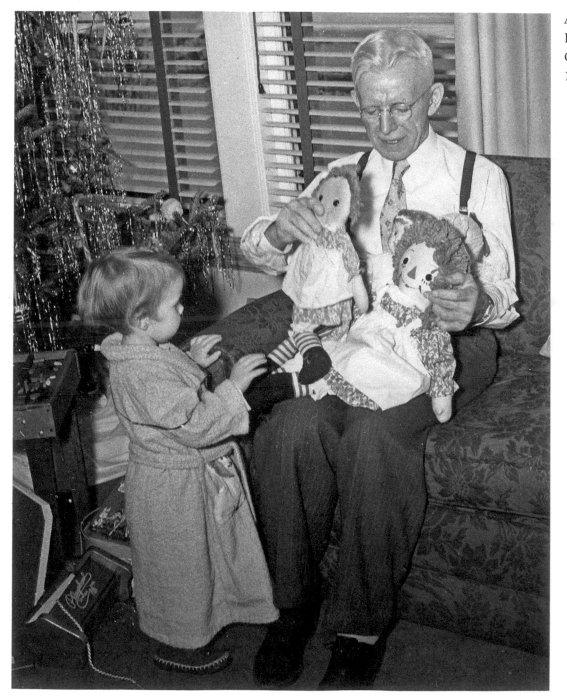

A little girl receives two Raggedy Ann dolls on Christmas morning, 1953.

The tradition of the holiday television specials reaches back to the early days of the medium. Here, Chicago's own Kukla and Ollie extend season's greetings.

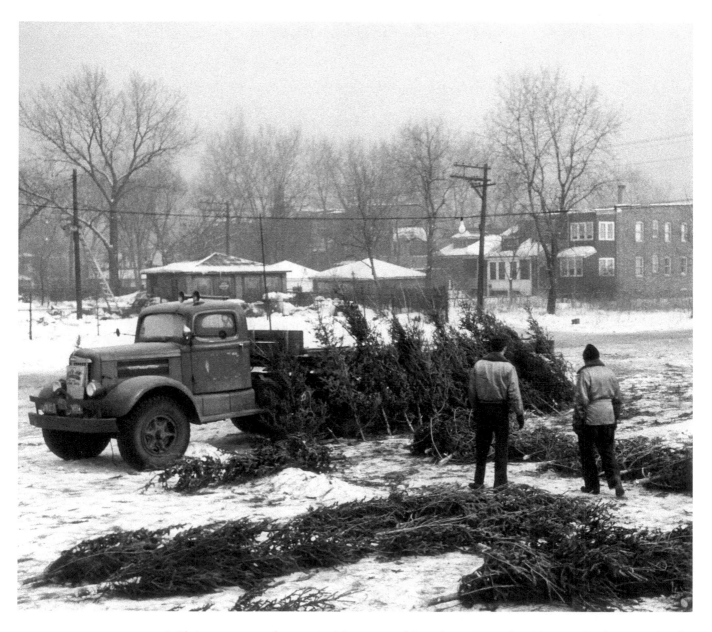

A Christmas tree market on 72nd Street east of State Street, December 23, 1951. By this time, decades after the demise of the famous ships, Christmas trees arrived by way of trucks.

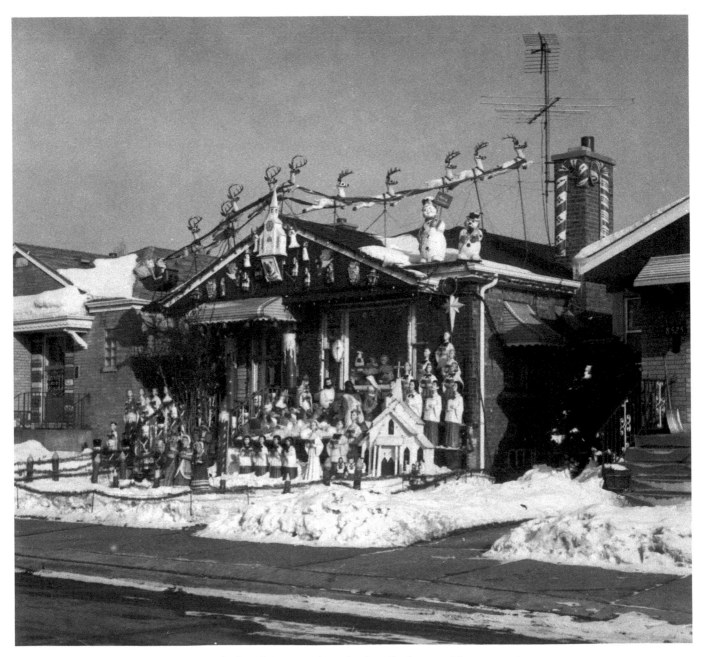

Many home displays mix the secular with the religious, such as this heavily decorated house seen in December 1969.

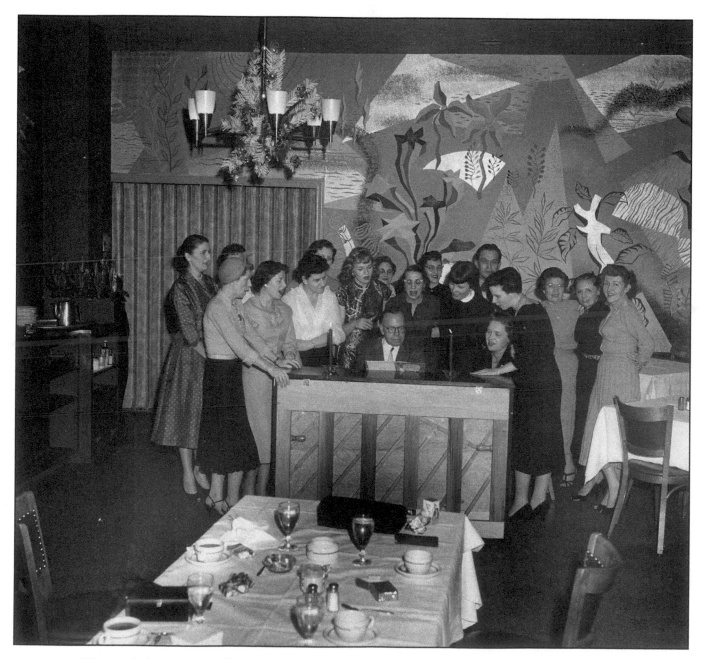

Home isn't the only place where people celebrate the holidays. Here, office staff gather with co-workers to sing carols.

Young people at a
tree-trimming party,
around 1950

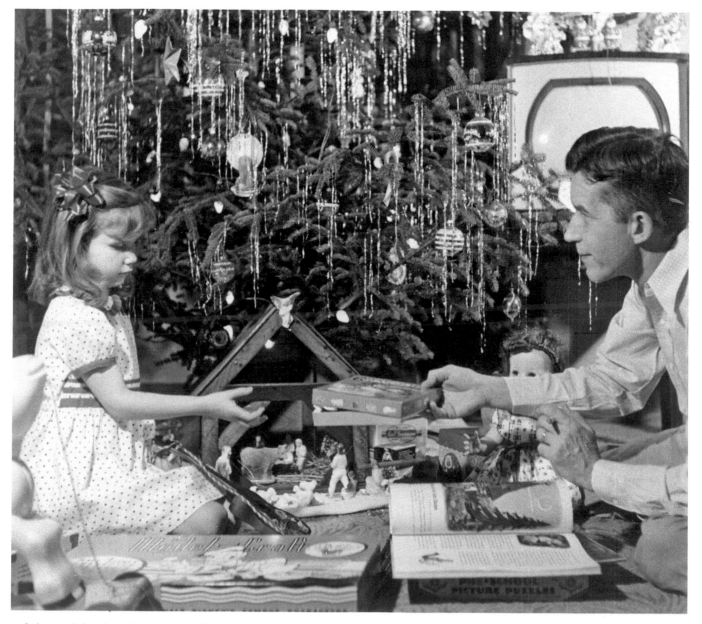

A father and daughter sit near their Christmas tree surrounded by an abundance of presents as well as a Nativity scene, around 1950.

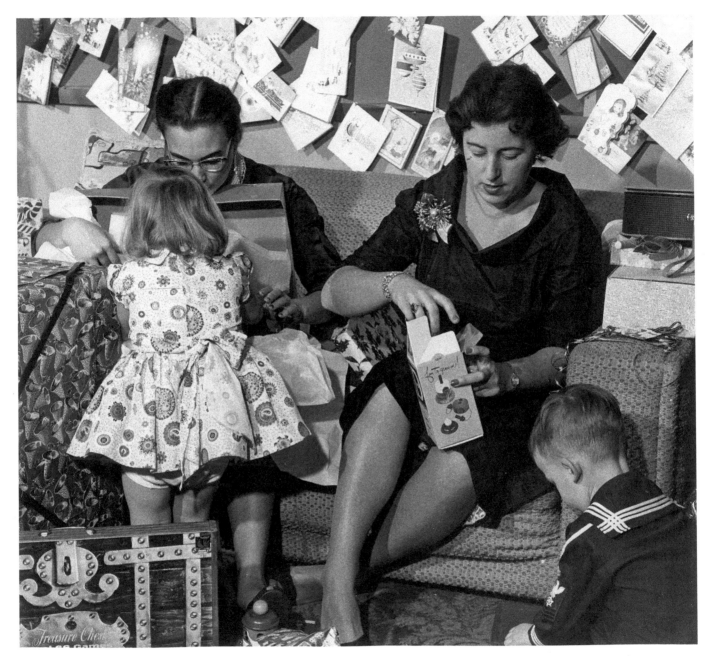

The Schmidt family opens presents on December 25, 1957.

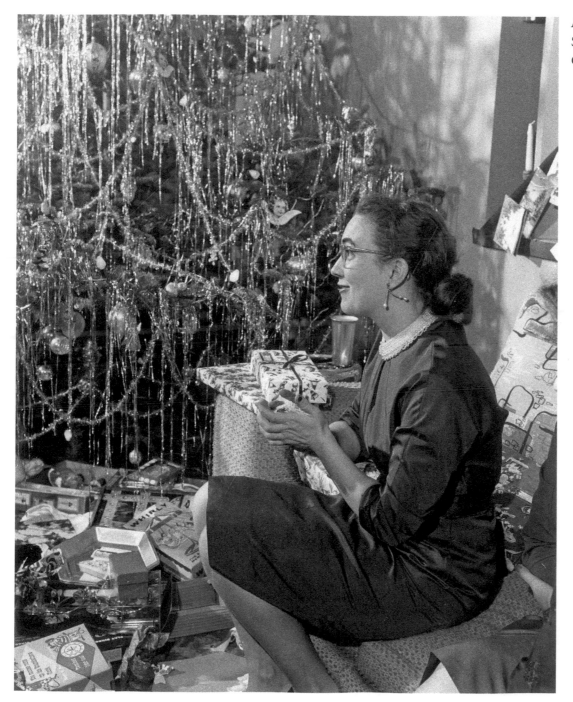

A member of the
Schmidt family at
Christmas.

A little girl in
pajamas warns
against even
whispering, in case
Santa is in the house
delivering presents.

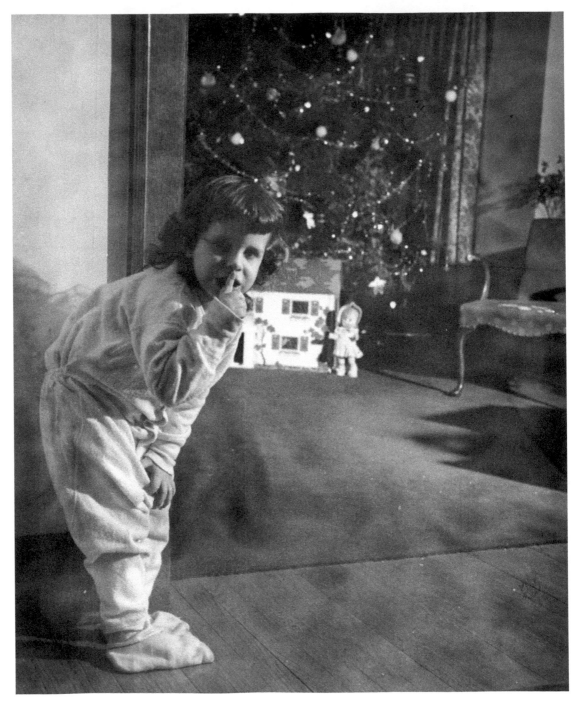

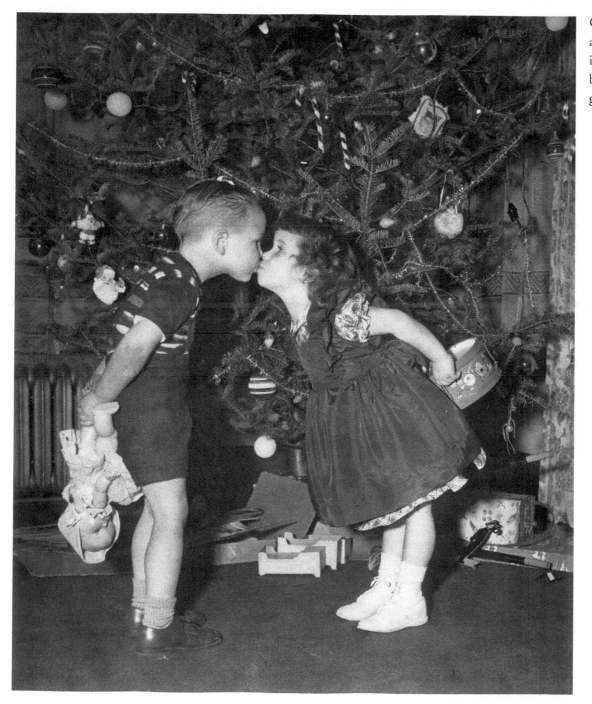

Children share
a Christmas kiss
in front of a tree
before exchanging
gifts.

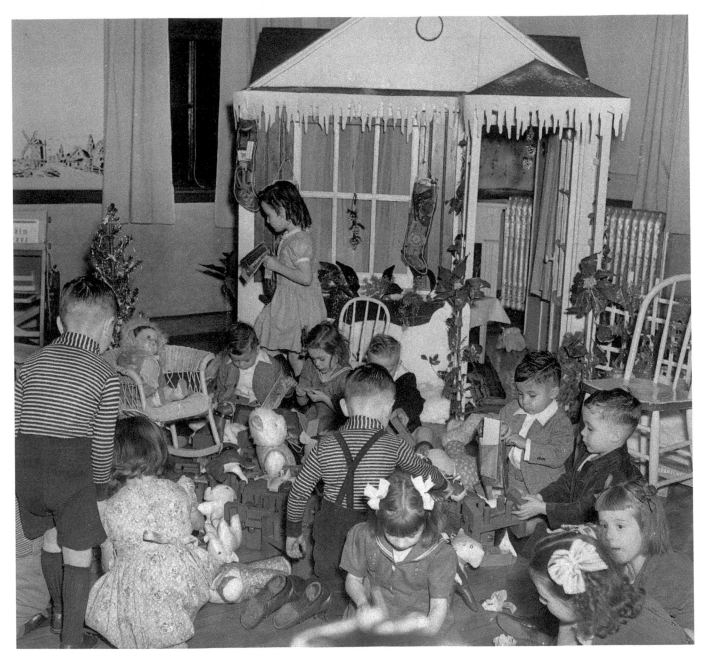

Children play with toys in a kindergarten classroom decorated for Christmas.

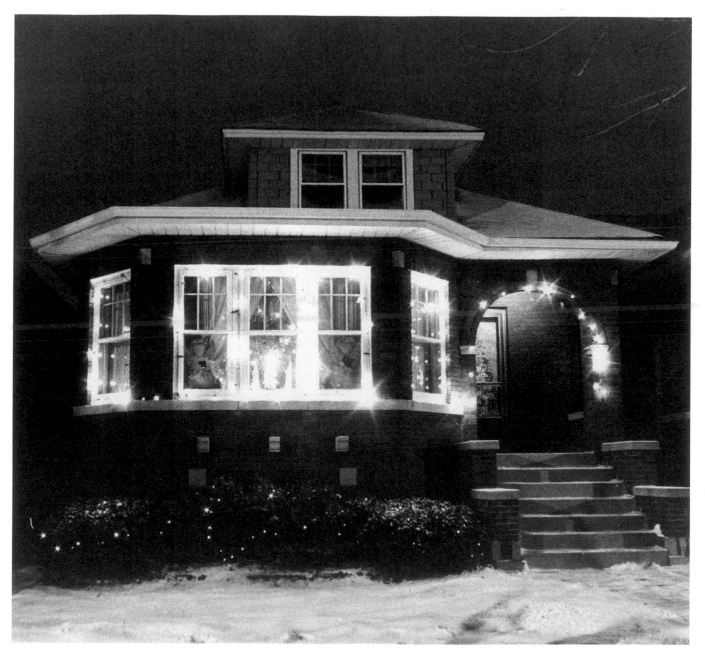

One of Chicago's famous bungalows is decorated for Christmas, around 1979.

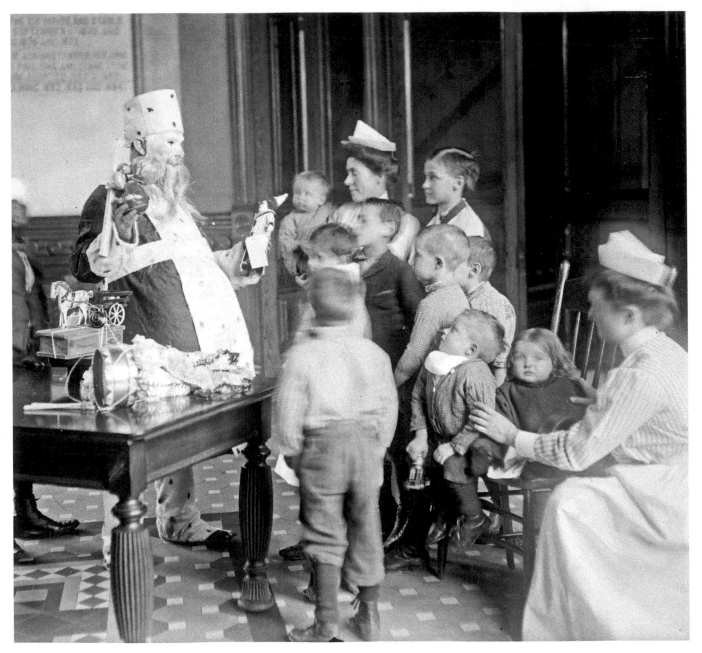

Santa (who wears not just a beard but a mask for his entire face) visits with young patients at Cook County Hospital in 1909. In the early 1900s, images of Santa often differed greatly from the rotund, rosy-cheeked, jolly gentleman we're used to seeing today.

Here Comes Santa Claus

St. Nick and Holiday Shopping

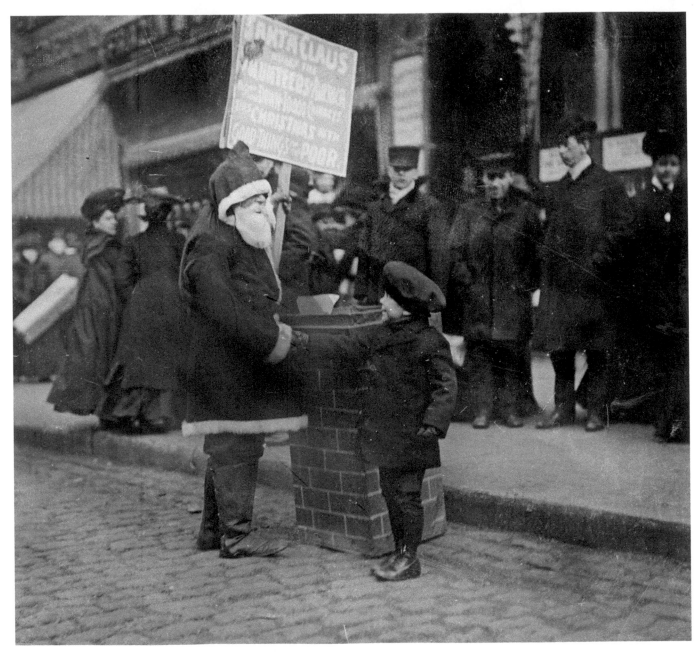

A young boy stops to shake hands with Santa, who is raising money to help Chicago's poor, around 1903.

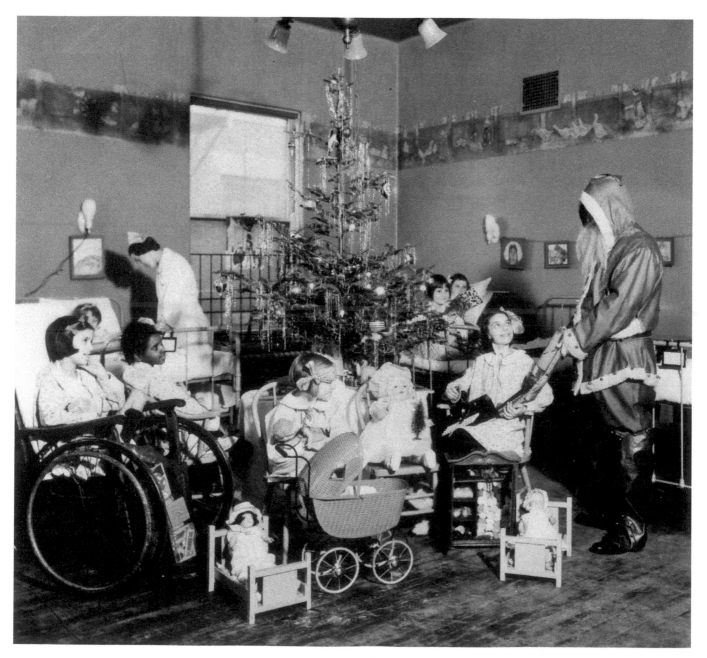

A lean, hooded Santa visits patients at Children's Memorial Hospital.

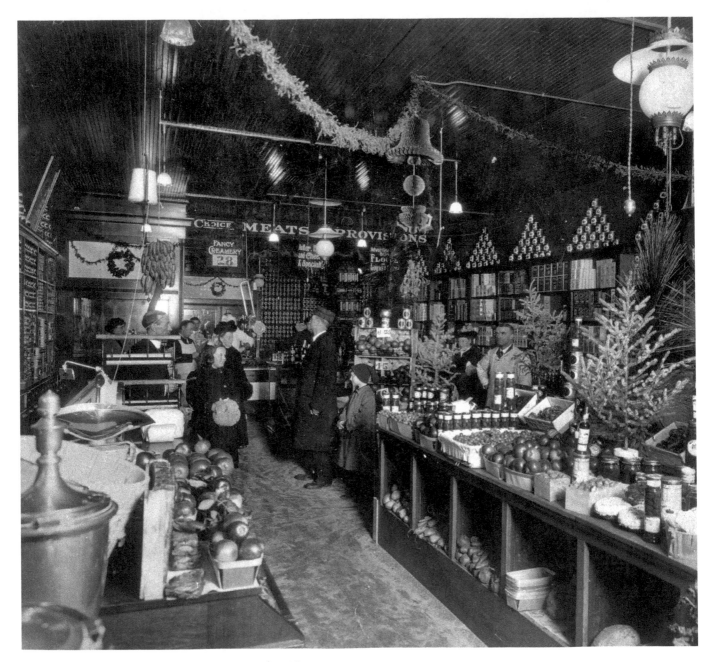

A grocery store decorated for Christmas, around 1900.

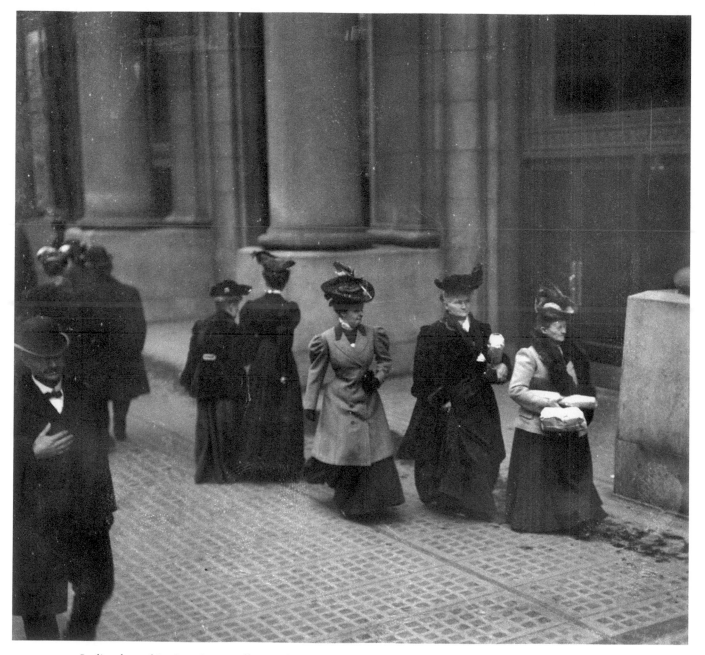

Ladies dressed in their finest walk past the main entrance to Marshall Field's while Christmas shopping, around 1905.

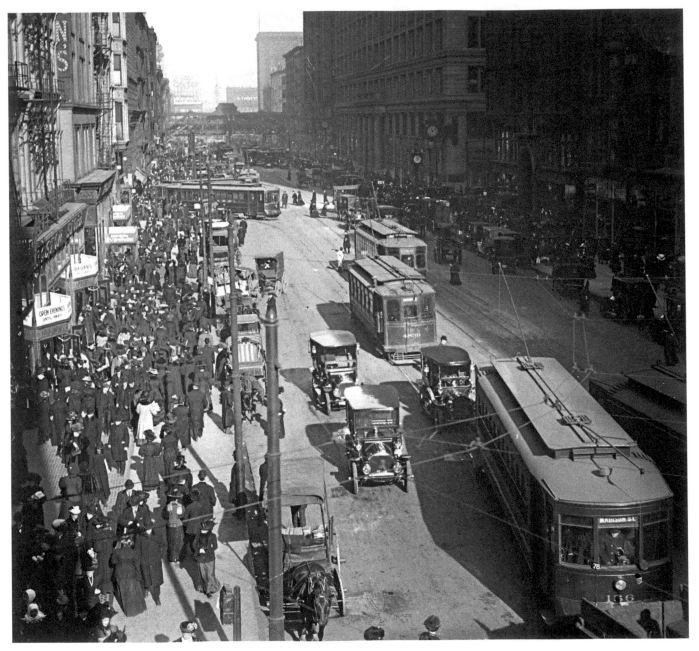

State Street bustles with shoppers in this image from 1909. The Boston Store, at the northwest corner of State and Madison, appears at left, advertising its extended hours for the holiday season.

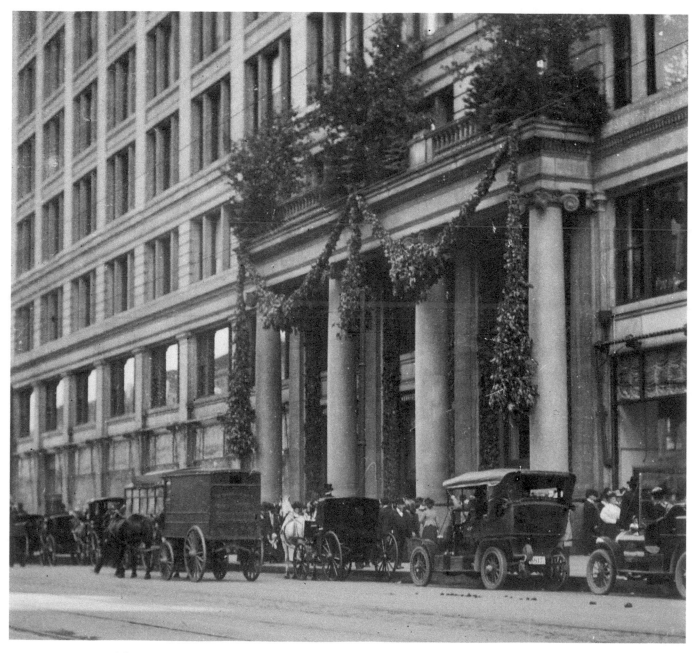

The main entrance of Marshall Field's on State Street, decorated with evergreen trees and swags, around 1907.

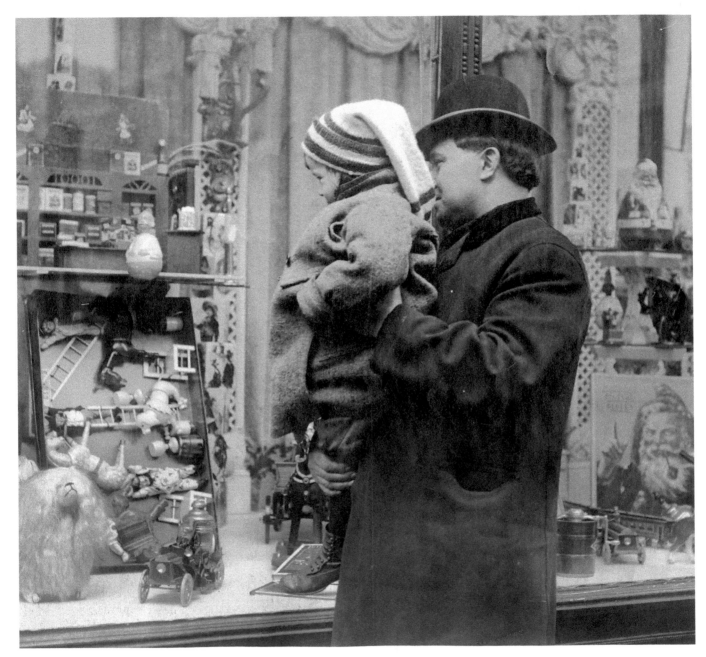

A father gives his child a lift to better view the Christmas goodies, around 1910.

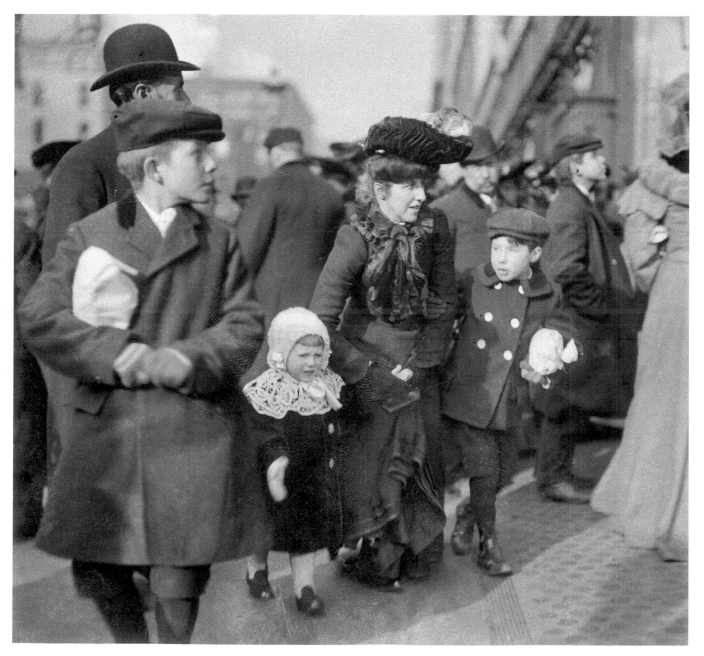

A woman steers her children through the busy streets while Christmas shopping, around 1915.

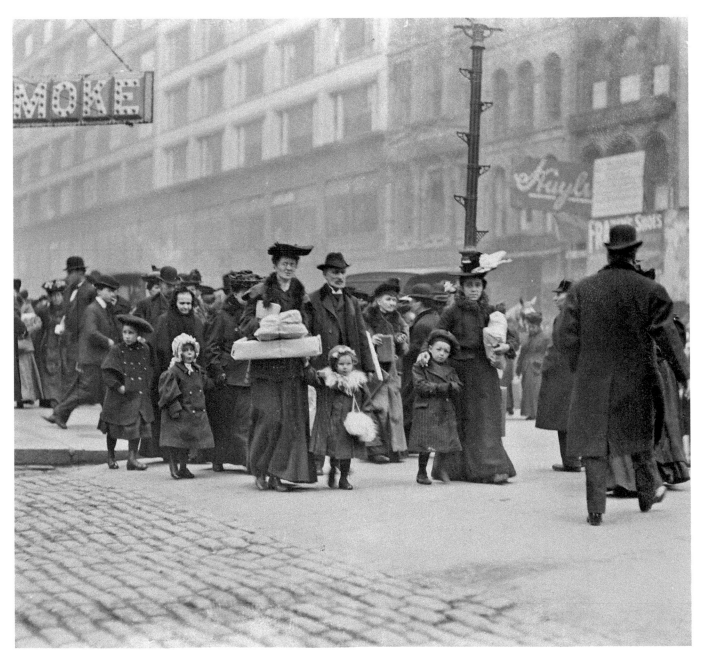

A crowd of Christmas shoppers crosses the street, around 1915.

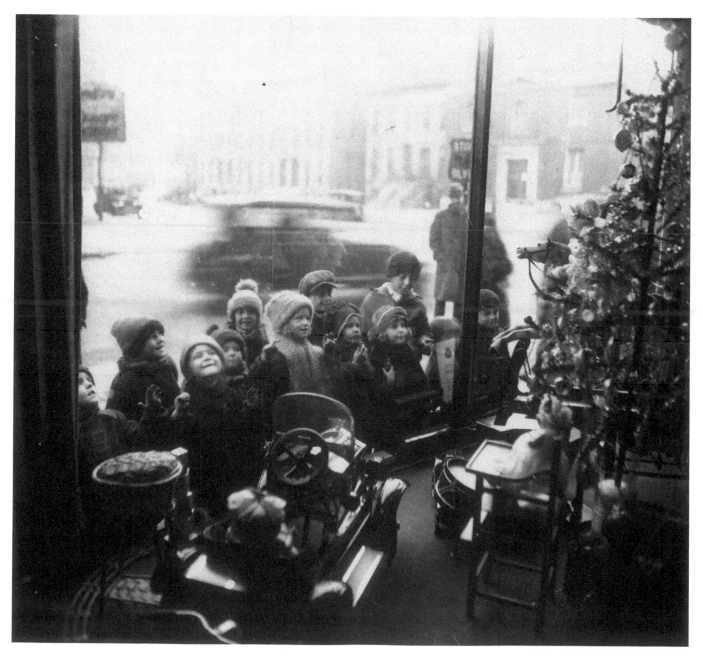

For children, the best window displays have always been the ones full of toys, such as this 1920s Christmas display.

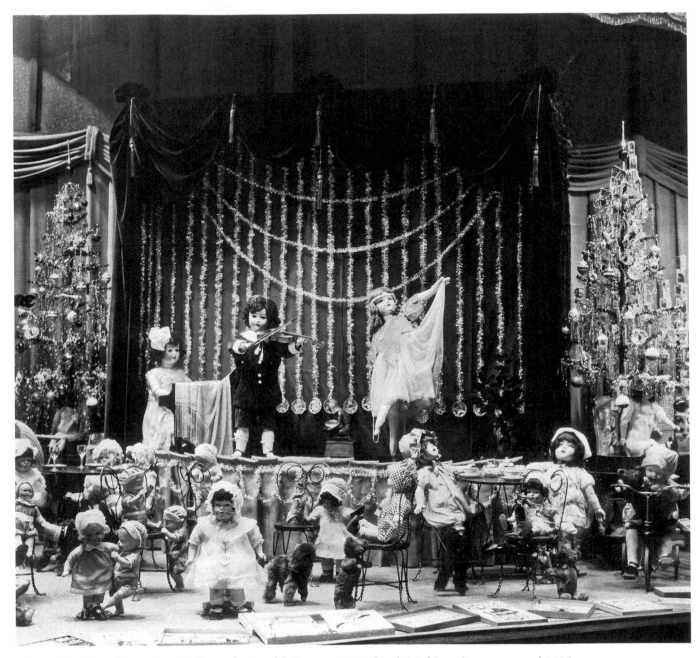

The "Doll Cabaret," a window display at the People's Store at 11201 South Michigan Avenue, around 1925.

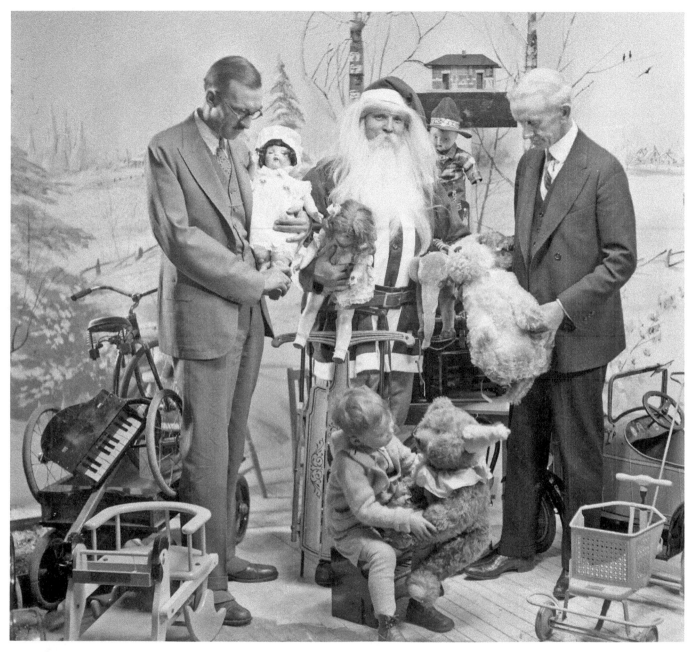

WMAQ radio personality Russell Pratt, at left, appears in a Christmas scene with Santa and surrounded by favorite toys, around 1927.

Not even Santa Claus could resist the excitement over "Lucky Lindy" and air travel. Here Santa tries out a substitute for his sleigh just months after Charles Lindbergh's famous 1927 transatlantic flight.

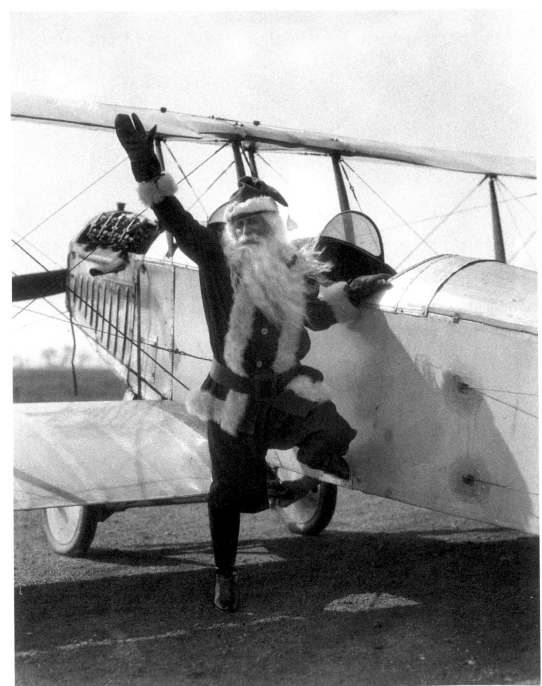

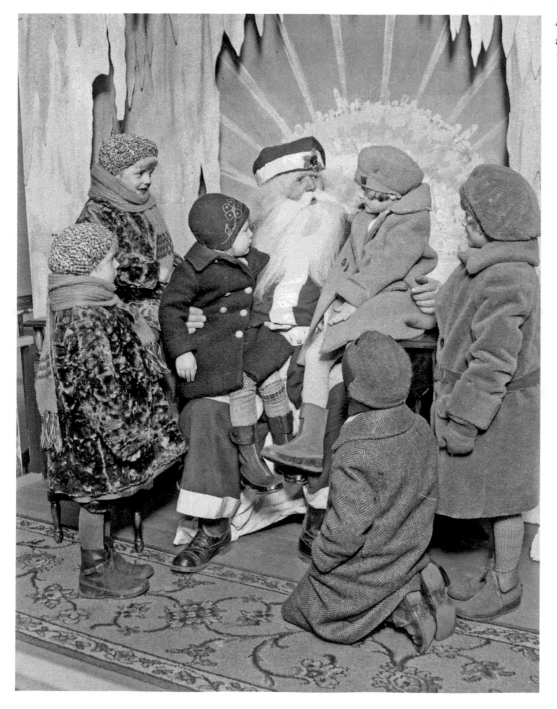

A group of children gather around Santa, around 1929.

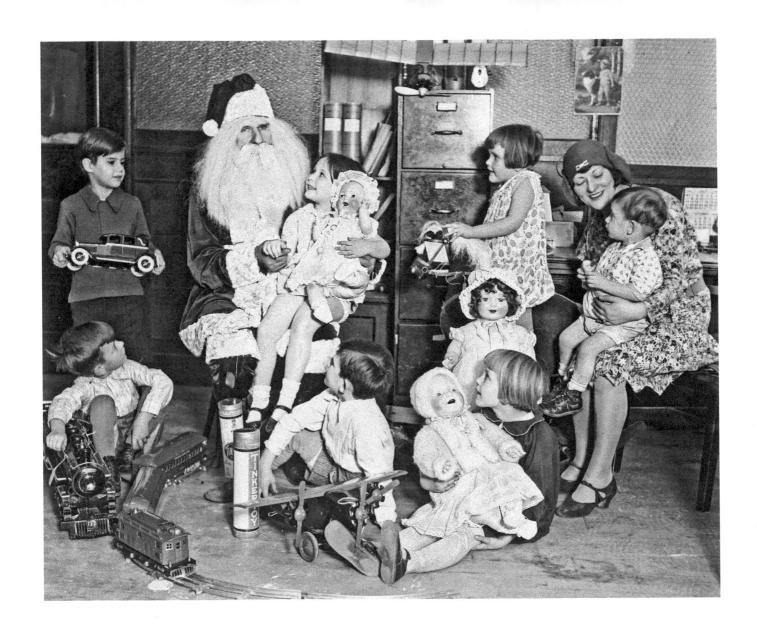

Santa Claus and children together in an office at the Fair Store, a department store located at State and Adams streets, 1929.

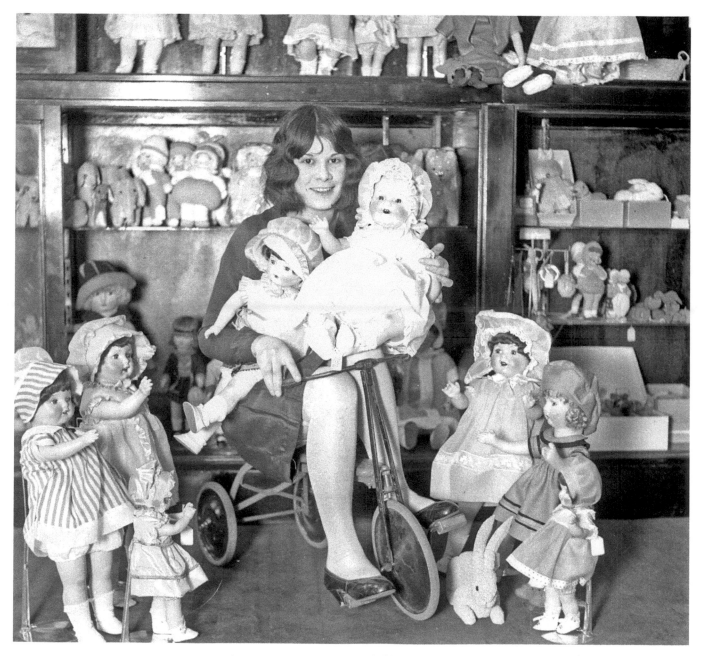

A young woman is surrounded by dolls, an all-time favorite Christmas gift, around 1928.

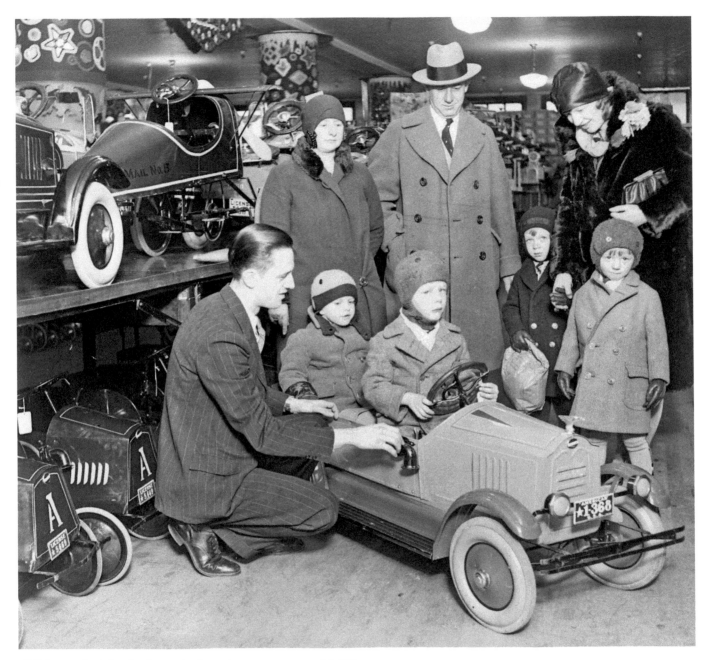

Children and adults check out the latest in toy cars, around 1929.

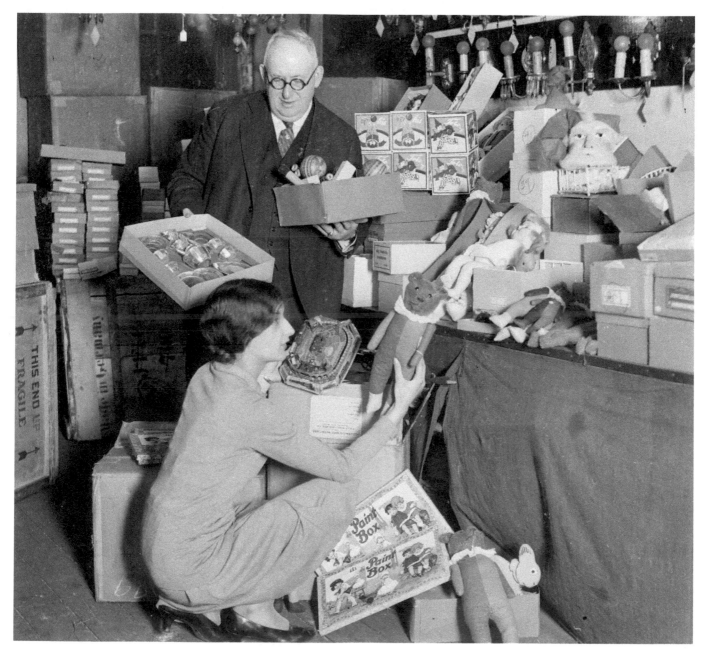

A man and a woman sort through toy stock in the back room of a department store, around 1929.

A woman prepares to enter a car with all of her packages in tow after a busy shopping trip, around 1929.

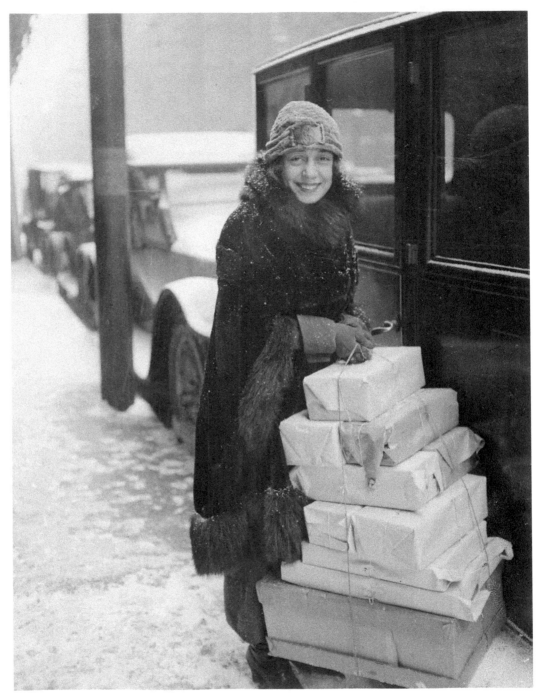

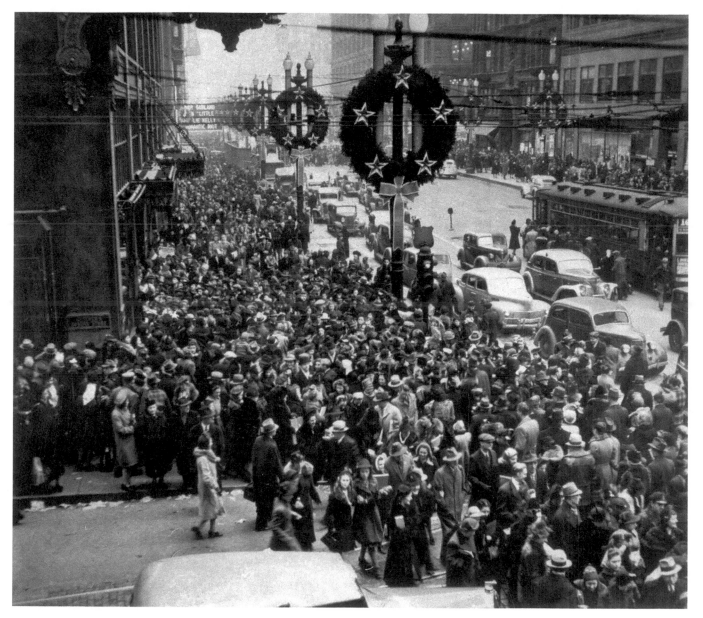

Huge crowds walk along State Street beneath Christmas wreaths decorating the thoroughfare.

Holiday shopping exhaustion has a long history in Chicago. Here, Frances Eureka rests after a tiring trip to the stores, around 1929.

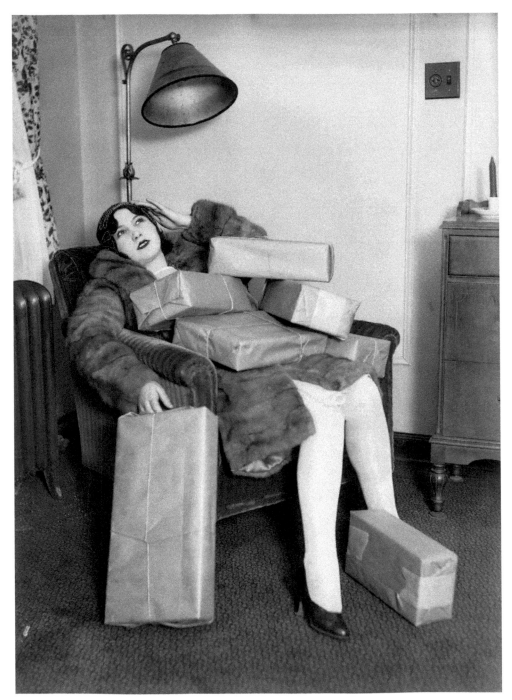

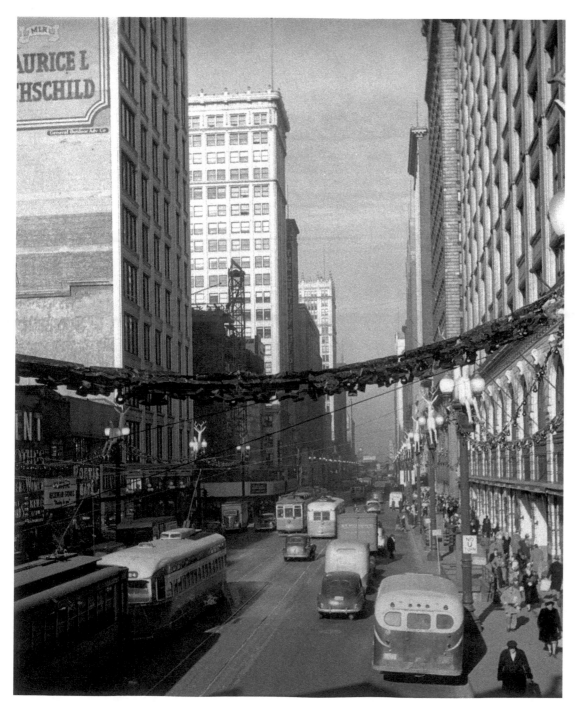

Vehicles take center stage in this mid-century view of State Street decorated with wreaths and lights for Christmas. In the 1970s, cars disappeared from the thoroughfare with the creation of the State Street Mall, an unsuccessful effort to revitalize the flagging commercial district. The mall was dismantled by 1997.

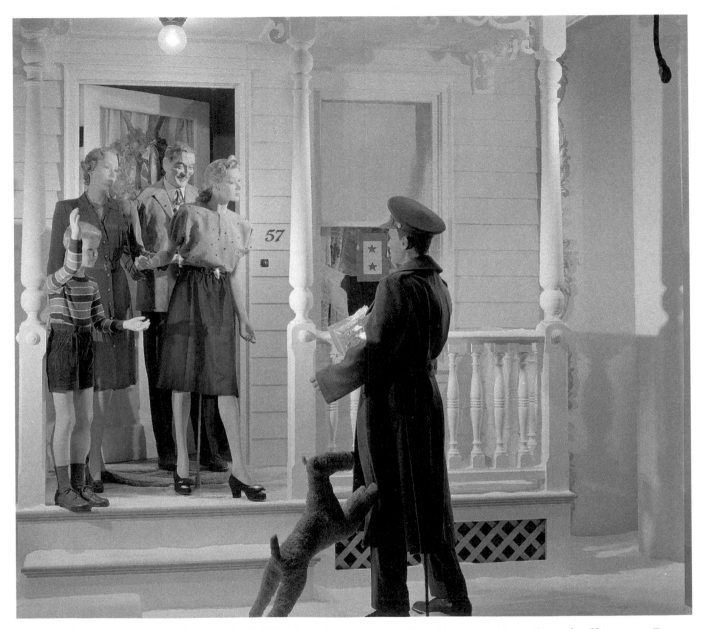

The Christmas-themed windows at Marshall Field's on State Street have long been a popular tradition for Chicagoans. For one holiday season during World War II, the windows' theme was "home for the holidays," and a variety of different homes was presented. In this window, a soldier arrives home at a Victorian-style house. The star flag in the window indicates the number of soldiers the family has serving in the war.

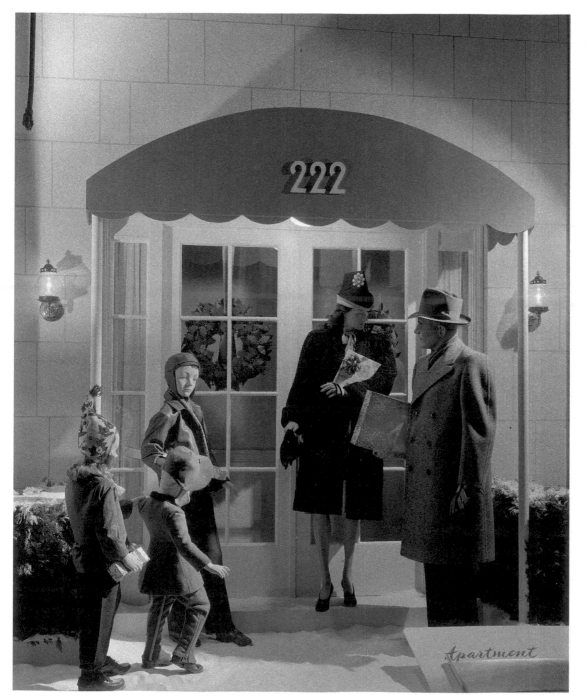

In this window display, a family preparing to celebrate the holiday gathers outside their apartment building.

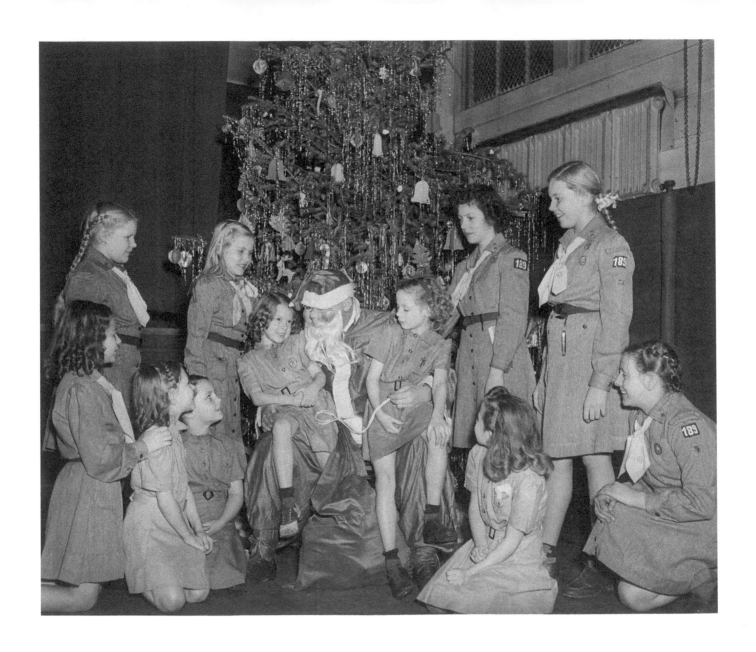

A group of Brownies and Girl Scouts visit with Santa Claus, Christmas 1945.

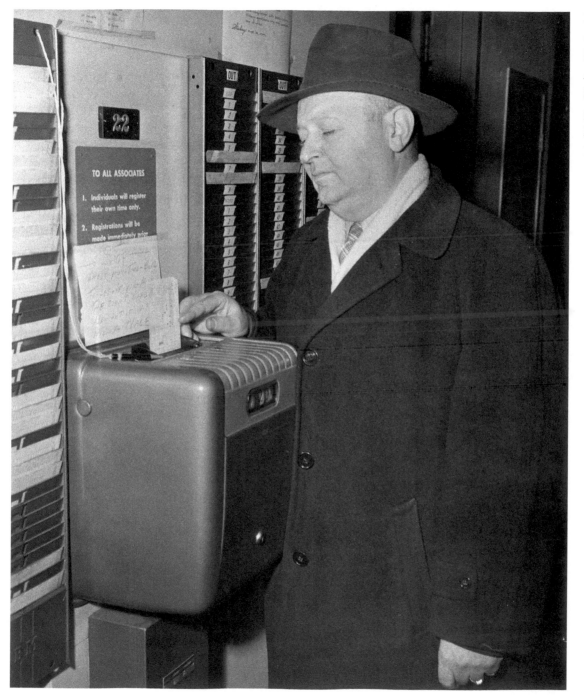

Even Santa has to clock in and change into work clothes. At Carson Pirie Scott, Pat Moran prepares to greet his public, around 1950.

Wieboldt's had several locations throughout the Chicago area. Here, shoppers search for the perfect presents, around 1945.

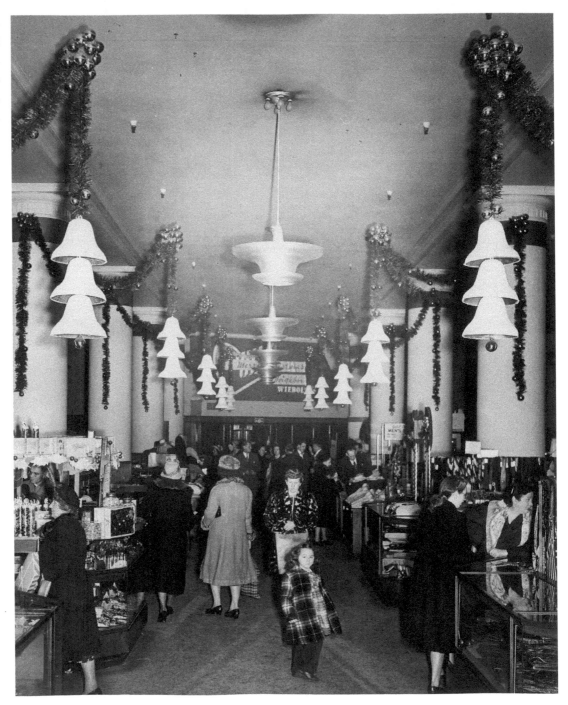

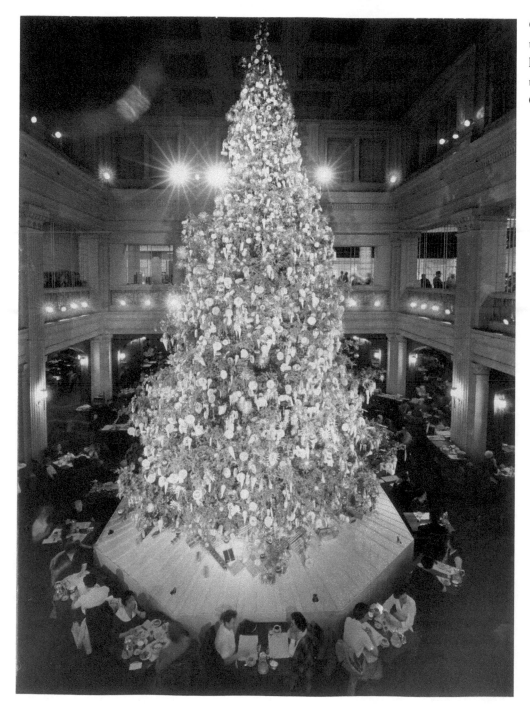

One of Chicago's most treasured Christmas traditions: lunch at the Walnut Room next to its immense tree, seen here Christmas Eve, 1954.

Decorations on the first floor of Marshall Field's, around 1955.

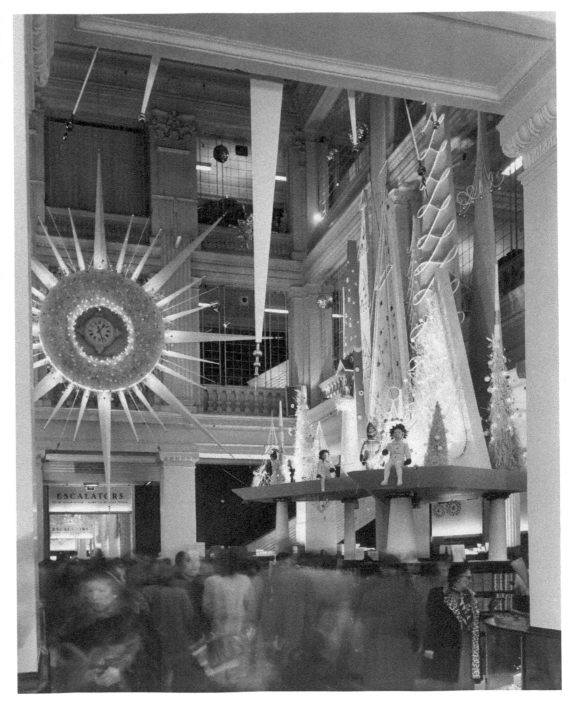

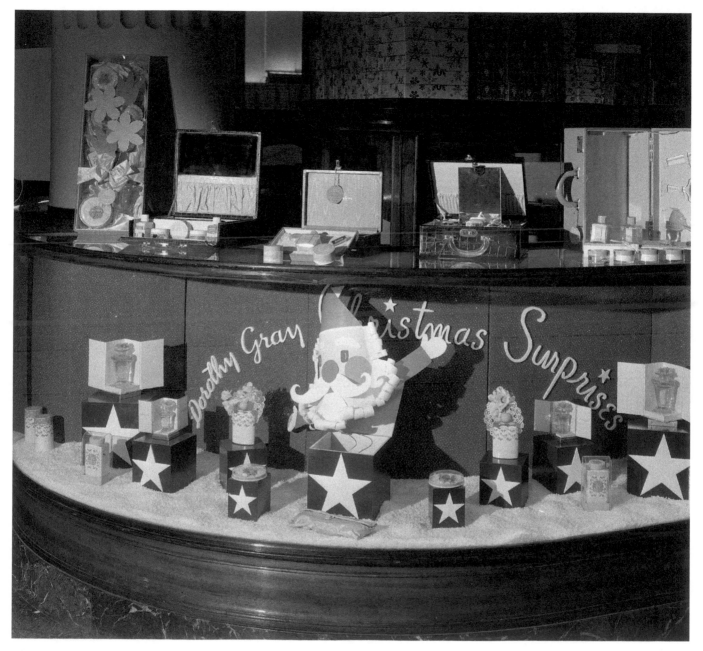

The cosmetics company Dorothy Gray created a display with a variety of suggestions for presents. The company began in the 1910s and was popular for many decades.

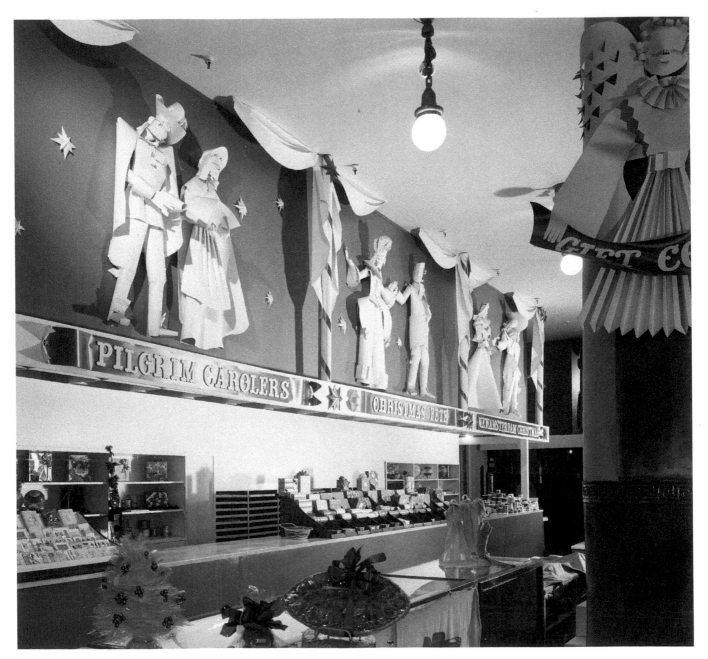

A gift-wrapping desk offers shoppers both a time-saving service as well as beautifully wrapped packages.

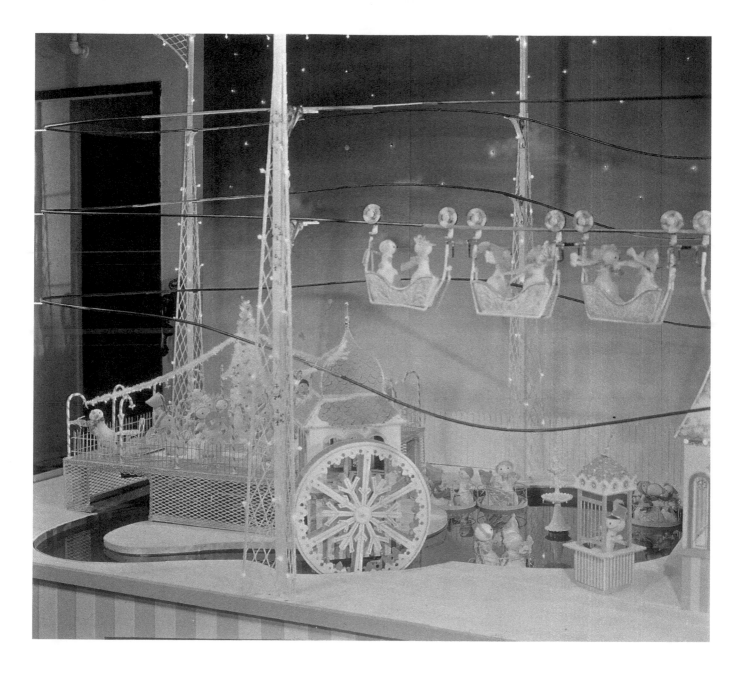

In a window of this store, an automated Christmas display features a miniature winter scene.

A cozy, nostalgic Christmas scene. The sheet music for "Silent Night" rests on the organ. The popular carol was first performed in Austria on Christmas Eve, 1818.

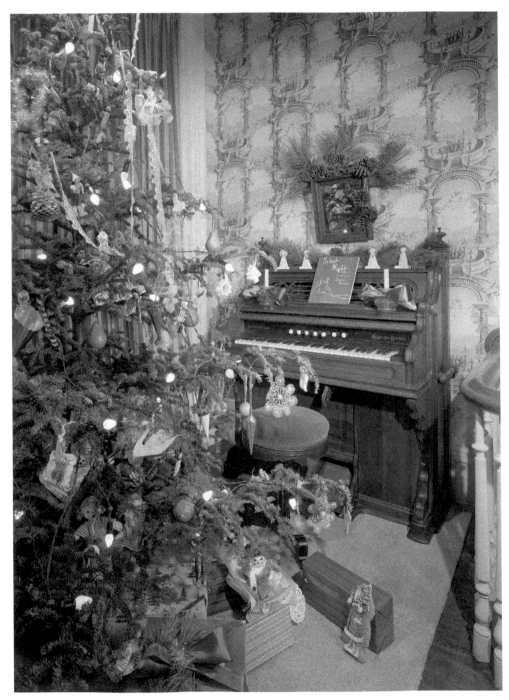

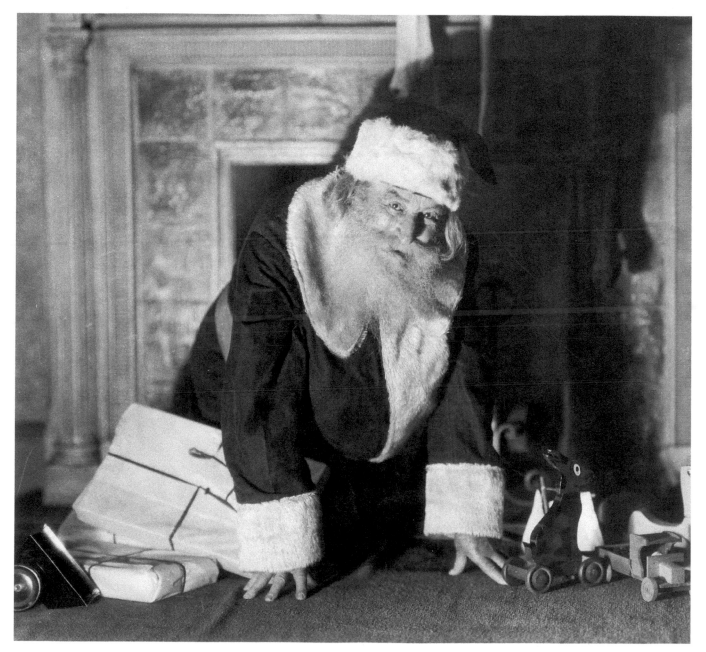

Santa Claus kneels near a fireplace as he delivers presents.

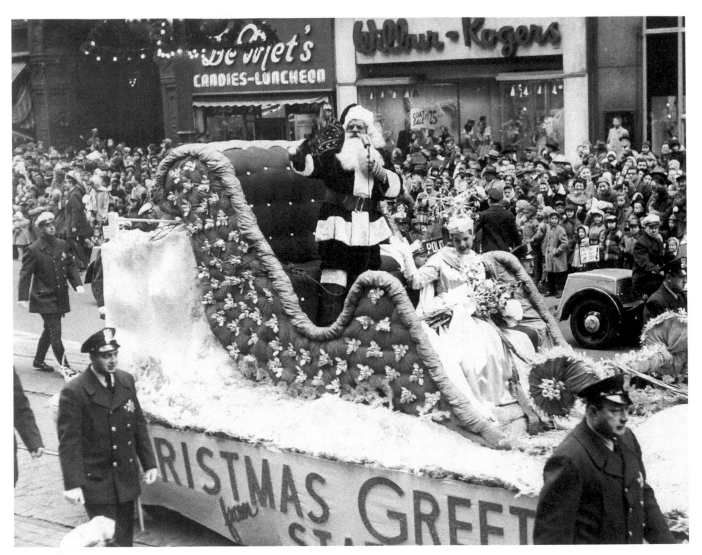

Santa addresses the crowd at the State Street Parade, November 22, 1954.

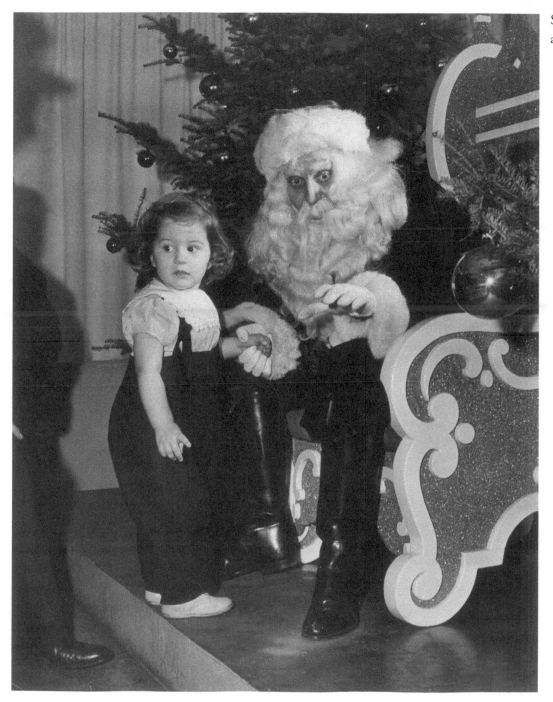

Santa with a young visitor
at Marshall Field's.

Christmas on State Street as viewed looking southeast from Randolph toward Marshall Field's grand facade, Christmas Eve, 1960.

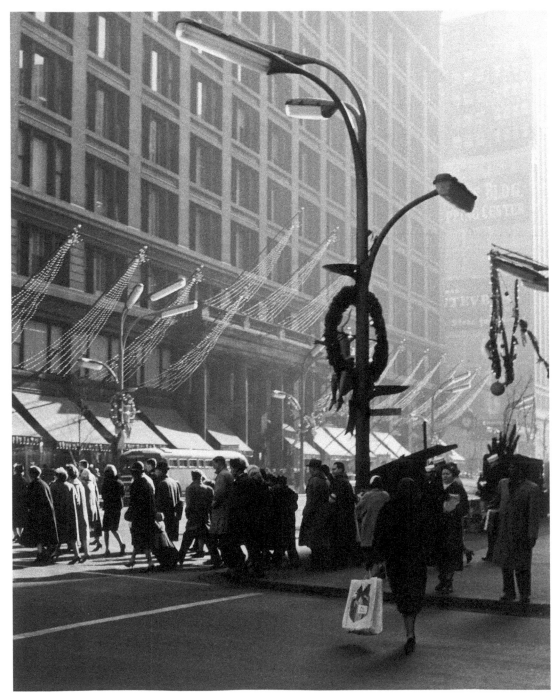

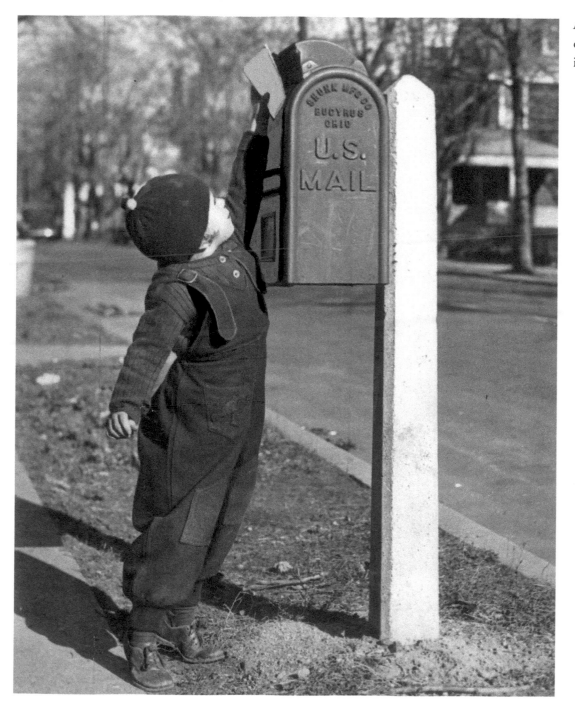

A little girl reaches to drop a letter to Santa in the mailbox.

Shopping at Marshall
Field's, Christmastime
1968.

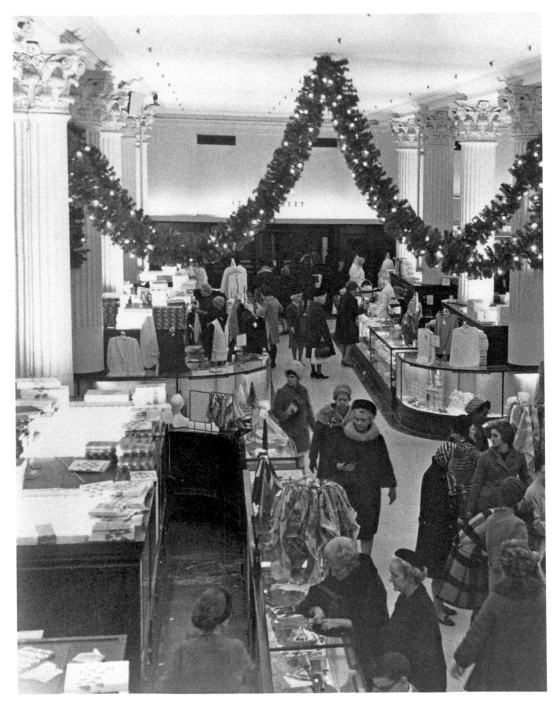

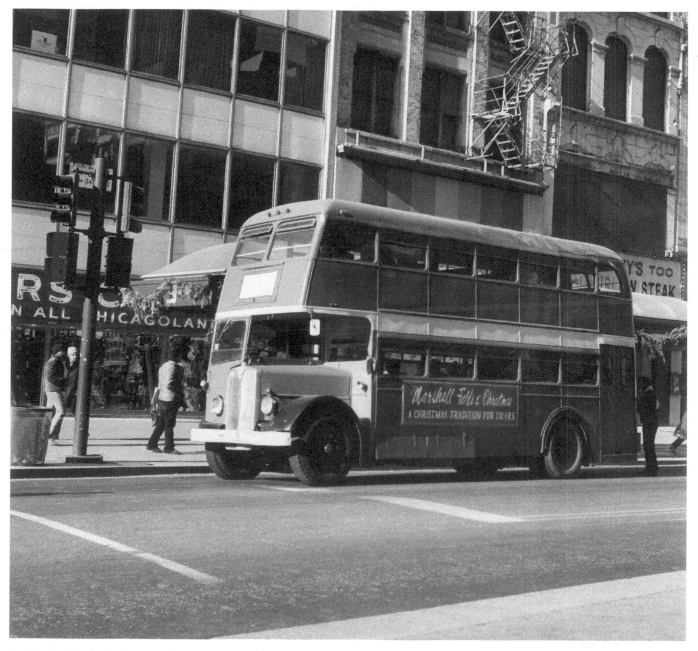

As this double-decker bus proclaims, for more than a century Marshall Field's has been a central part of many Chicagoans' holidays.

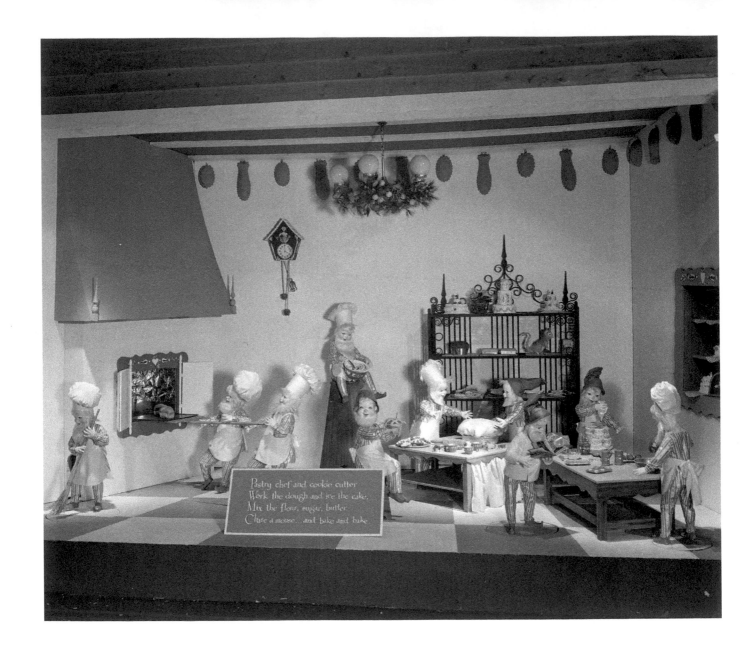

This window depicts elves baking Christmas goodies.

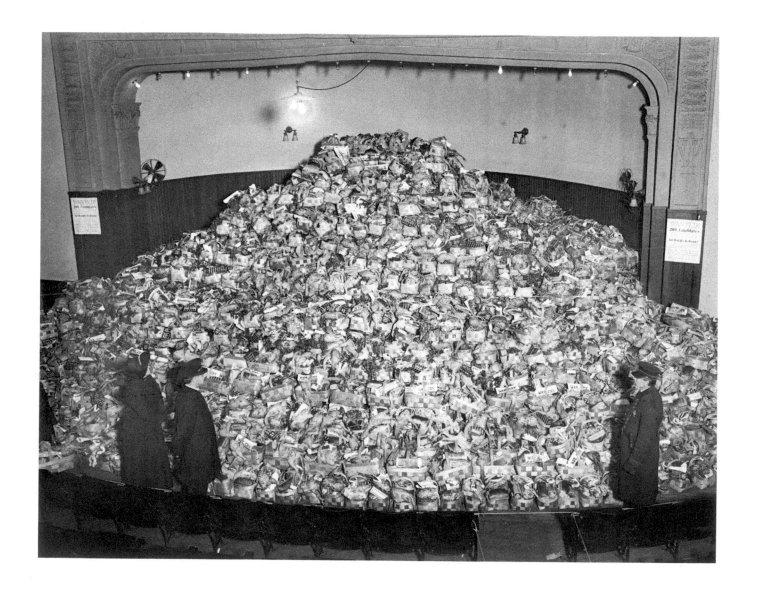

A stage covered with Salvation Army Christmas baskets. Founded in London in 1865, the Salvation Army arrived in Chicago in 1885 and soon became one of the most active social-service organizations in the city.

Notes on the Photographs

These notes, listed by page number, attempt to include all aspects known of the photographs. Each of the photographs is identified by the page number, a title or description, photographer and collection, archive, and call or box number when applicable. Although every attempt was made to collect all data, in some cases complete data may have been unavailable due to the age and condition of some of the photographs and records.

Printed in the USA
CPSIA information can be obtained
at www.ICGtesting.com
JSHW072023140824
68134JS00042B/3764